IMAGES
*of America*

# BALTIMORE'S
# DEAF HERITAGE

*Kat Brockway*

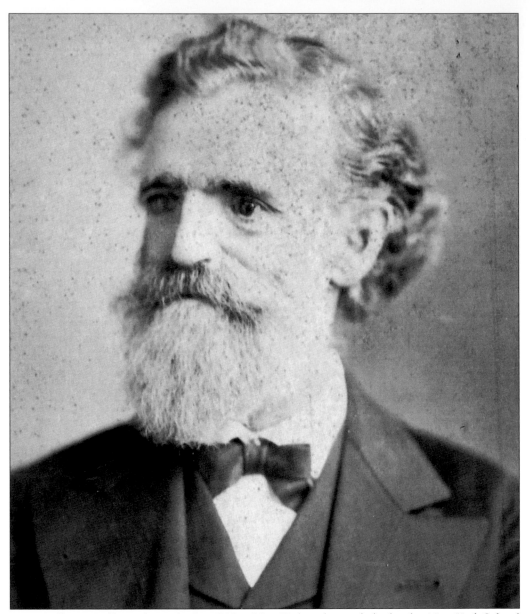

James Sullivan Wells was born deaf in 1832 in New York and attended school at New York School for the Deaf (NYSD) at Fanwood with his deaf sister Rhoda. He graduated from NYSD in 1851 with famous classmates Charles Milan Grow Sr. and Lucinda E. Hills. Grow and Hills taught at Maryland School for the Deaf (MSD) in 1868 as the first teachers. Wells later moved to Texas at the urging of Jacob van Nostrand, a fellow teacher from NYSD and the superintendent of Texas School for the Deaf (TSD). There, Wells became one of the first teachers at TSD. (Courtesy of Lee Berenson.)

ON THE COVER: Taken in April or May of 1883 at what was believed to be one of the popular Deaf hangouts, the Druid Hills Park, this image shows someone signing to the Deaf watchers. Everybody was dressed up for the festivities on that day, either Easter or May Day. (Courtesy of Christ Deaf Church.)

IMAGES
*of America*

# BALTIMORE'S
# DEAF HERITAGE

Kathleen Brockway

ARCADIA
PUBLISHING

Copyright © 2014 by Kathleen Brockway
ISBN 978-1-4671-2193-4

Published by Arcadia Publishing
Charleston, South Carolina

Printed in the United States of America

Library of Congress Control Number: 2013954120

For all general information, please contact Arcadia Publishing:
Telephone 843-853-2070
Fax 843-853-0044
E-mail sales@arcadiapublishing.com
For customer service and orders:
Toll-Free 1-888-313-2665

Visit us on the Internet at www.arcadiapublishing.com

*To the descendants of the James Sullivan Wells family, especially Lee Berenson, who was very devoted to working with me on this personal project, which made a difference in gaining recognition about more early Deaf leaders and knowledge of local Deaf history*

# CONTENTS

# ACKNOWLEDGMENTS

When I first started to know the descendants of the earliest families of Deaf leaders, I knew I had to write and share with others. Without the vintage photographs, the book would not have been possible. I wish to thank my editor at Arcadia Publishing, Julia Simpson, for her guidance and patience. There are several people who have given themselves to this book through their researching of local history. I give heartfelt thanks to Lee Berenson; Lana Leitner Butler; Elinor Reese; Milbert and Zelephiene Jennings Jones; Joyce Jacobson Leitch; Lois Cooper Markel; Eugene and Manuel Rubinstein; Charles E. Moylan Jr. and his wife, Marcia; Stacie DeLespine Wright Gill; Jeri Dilworth Miranda; Michael Olson and Christopher Shea from the Gallaudet University Archives; Chad Baker, Linda Stull, and Lawrence Newman from the Maryland School for the Deaf Museum; Michael Bina, the superintendent of the Maryland School for the Blind; Michael Hudson; Robert Geary Photography; Bishop Peggy Johnson; Arlene Blumenthal Kelly; Kathi Jeffra and Sandie Johnson from Christ Deaf Church; Alfred Sonnenstrahl; Deborah Meranski Blumenson; Simon Carmel; Harriet Grossblatt and Louis Greenberg; Fleet Bowman; Steven Brenner; Robert Herdtsfelder; Jason Dietz; Kappa Gamma fraternity members; Dr. Ernest Hairston; Paul McCardell at the *Baltimore Sun* newspaper; especially to Tina Koopman for her tremendous patience and encouragement; and to many more for contributing toward preserving our community's Deaf heritage.

The following are frequently used abbreviations in the Deaf community and in this book: the American Athletic Association of the Deaf (AAAD); American Sign Language (ASL); F.F.F.S. (the abbreviation is as is—it is a secret society for the Baltimore Ladies); Honor of Secret Society (H.O.S.S.); the Maryland Association of the Deaf (MAD); the Maryland School for the Deaf (MSD); the Maryland School for Deaf Colored Youths (often called the Overlea School); the Maryland School for the Deaf Alumni Association, formerly known as MAD (now MSDAA); the National Association of the Deaf (NAD); the National Fraternal Society of the Deaf (NFSD); the Southeastern Athletic Association of the Deaf (SEAAD); the Silent Clover Society (SCS); the Silent Oriole Club (SOC); the Virginia School for the Deaf and Blind (VSDB); and the Youth Silents Club (YSC).

# INTRODUCTION

In 1879, at the urging of family friends, James Sullivan Wells (48) and his family—his three small children Clarissa, Fannie, and Helen and his wife, Fannie F. DeLespine Wells—decided to move to Baltimore, which was a new place for them away from their native New York City. By then, the Deaf community in Baltimore was starting to boom, and Deaf Baltimoreans were beginning to spend time together and worship together. Soon after Wells's arrival, he and his close family friend William Barry drew many into a group that attracted George W. Veditz, Frank and George Leitner, and many others. All became fast friends and leaders in the community, establishing events, organizations, and activities. Wells was the beginning of a three-generation family of Deaf leaders, which joined others to work together to fight for Deaf driving rights, Deaf political rights, and more. Some lived on farms, and some lived in row houses in the busy city.

Religions were varied in the Deaf community. Nonetheless, they all got together on a frequent basis, even on occasions like Easter Sunday church services, either outdoors or indoors. Getting together created a comfort zone, and they celebrated events in sign language. Deaf Jewish individuals did not always get together at the temple; instead, they hosted parties for the Deaf. In the 1800s and 1900s, the temples and other churches were difficult to attend due to the lack of interpreters and resources.

Education was important to every parent of a deaf child. Only one local school accepted deaf children under age five of all religions, the Catholic School in Baltimore. Some others received private tutoring. Schools were split in signing and oral methods, leaving it up to parents to make decisions about where to place their children. Some were sent to MSD, an all-state-expenses school that children traveled to by horse coach, train, or vehicle. Traveling to MSD was considered a long trip, so children had to stay and live on the campus, seeing their families infrequently during their school years. There was also an oral school in Baltimore that forbade sign language. Some grew up attending that school and went on to their local high schools, which did not have any interpreters. The Black Deaf community at the time had very limited choices, as students could only attend the Kendall School in Washington, DC, or the Maryland School for Deaf Colored Youths in Baltimore. Some may have not been educated at all, and worked only with their families. At the time, the Kendall School was known to teach orally. Some students paid tuition fees, while others were covered by the state if they got the government's permission. One of the first black Deaf teachers in America, Harry Leonard Johns, was from Baltimore. He taught at the Texas School for the Deaf (TSD) before returning to Baltimore, joining his deaf brother Leonard Carroll Johns in a large family on the Ostend Street.

Organizations were already starting to form by 1884. Some were set for a purpose, such as socializing, reunions, religion, political groups to fight for Deaf rights, and many more. In the 1800s and 1900s, the annual reunion cookout was a popular activity, and attendees enjoyed participating in the games and winning prizes. Games included baseball, horseshoes, and others.

Groups rode the ferry together from the Maryland mainland to Bay Ridge for the cookout and swim at the beach. A bridge was built to Bay Ridge in the late 1950s.

Baseball, boxing, football, and soccer were popular in the late 1800s and early 1900s at the Deaf schools. Later, in the late 1900s, softball games were established so Deaf teams could enjoy the challenge of playing against hearing teams. Some had to pay out of their own pockets or raise money to play. In the mid-1900s, deaf adults started to form city basketball teams to play against Gallaudet or MSD. Many teams did not practice in those days; they just went to the games, warmed up, and played. For the Black Deaf community, popular activities included attending social clubs at volunteers' homes and going bowling in their best outfits. Many in the Black Deaf community could not afford certain things, including taking pictures to remember fun activities. However, Methodist Deaf Church, which later became Christ Deaf Church, welcomed them to join for worshipping.

Often, families with deaf children were split between signing and oral communication methods. Some parents forbade their deaf children to communicate by signing. Gestures were often used in limited communication if signing was not permitted. A few did manage to learn finger spelling or some signs to stay close with their Deaf siblings. In the 1900s, the city of Baltimore became more willing to listen and adapt to Deaf rights, such as allowing independent Deaf driving. Much appreciated in the fight for rights was the assistance of children of deaf adults and adults who had deaf children.

Throughout its weaving history, Baltimore's Deaf community has expanded, and many prominent Deaf leaders have been recognized. However, some have not yet been recognized. Hopefully, the publication of this book and the availability of its vintage images will lead to the recognition of more early Deaf leaders and inspire future role models for the Deaf community nationwide.

# One

# EARLIEST FAMILIES OF
# DEAF LEADERS

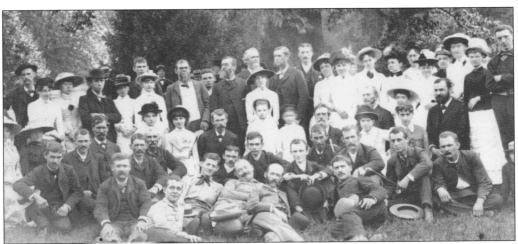

Shown here in 1884 is one of the annual Deaf cookouts, which were founded by James Sullivan Wells and William Barry, the Deaf community's liaison and Wells's close family friend. Wells is on the third row, third from the right with his daughters Helen and Fannie. Barry's daughter Annie is sitting in the fourth row, second from the right, and Barry is standing eighth from the left, next to Charles Ely. George Veditz is standing on the far right. (Courtesy of Christ Deaf Church.)

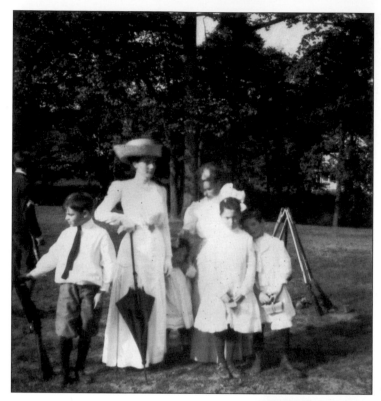

Fannie F. DeLespine came from the early Florida family of DeLespine. Her father brought the family to Texas from Florida. She was enrolled at TSD, where James taught and their paths crossed. They got married in 1871 in a double ceremony together with Fannie's sister, Florida. The family headed to New York City in 1873, then to Baltimore in 1879. Fannie is second from left next to her children, Clarissa, Helen, and Fannie, in this 1883 image—the very last photograph taken of her. (Courtesy of Lee Berenson.)

Four months before Helen Wells (pictured on the right) registered at MSD in 1883, her mother and youngest sister, Clarissa, died within a week of each other. Fannie's cause of death was listed as "hepatic abscess," an illness that lasted seven weeks, according to the death certificate. Clarissa succumbed to "cerebral effusion," resulting from a head injury. This illness lasted for six days, since the day of her mother's death. Helen's sister on the left, Fannie, was hearing. (Courtesy of Lee Berenson.)

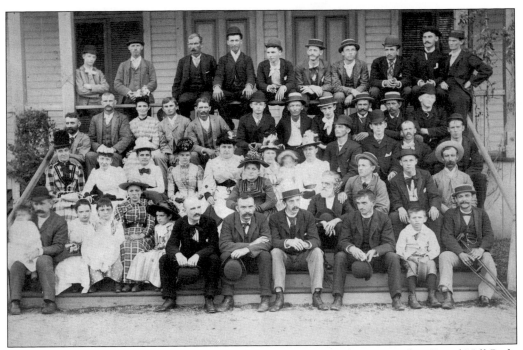

The annual Deaf cookout at Bay Ridge was a popular event. It later moved to Druid Hill Park. In this 1887 photograph, Helen Wells (later Leitner) is third from the left in the first row, Fannie Wells (later McCall) is sixth from the left, George W. Veditz is ninth, and Frank Leitner is tenth. James Wells is sitting behind Veditz and Leitner. Daniel E. Moylan (second from the upper right in the back row) had just graduated from MSD that year. Wells started the Grace Deaf Mission as a lay reader, which he did for 12 years. After Wells's death in 1891, Frank Leitner was offered to be lay reader, but he declined. Moylan then gladly took over as lay reader. Eventually, Leitner became a lay reader in Pittsburgh. In the February 1920 *MSD Bulletin*, Veditz remembered that Wells was also an excellent cook and a true gentleman. (Courtesy of Christ Deaf Church.)

Helen D. Wells Leitner (in front, with her niece Maureen on the right) graduated from MSD and continued working as a Deaf community leader in her father's footsteps after his death in 1891. In 1897, she married a deaf professional baseball player, George Leitner, who was also involved in activities with her, along with Annie Barry, William Barry's daughter and also Helen's godmother. (Courtesy of Lee Berenson.)

George M. "Dummy" Leitner (left and below), as he is remembered in baseball history, played with Luther "Dummy" Taylor. Leitner is recognized in the Baltimore Deaf community as one of its important leaders. Leitner was born in Parkton, Maryland, in a large family, including his deaf sister Lydia and deaf brother Frank. All three went to the Kendall School in Washington, DC. Lydia died just prior to her graduation from Kendall. (Both courtesy of Lee Berenson.)

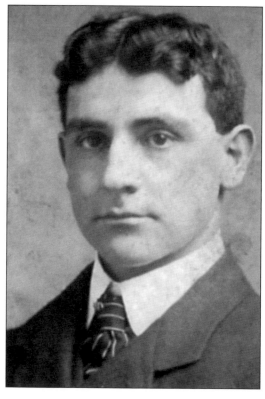

From left to right in this c. 1899 photograph, Helen Leitner holds her hearing son, Clarence Wells Leitner, with her husband, George, and close family friend Mrs. L. Brushwood. The Brushwood family was also involved in the Deaf community leadership. Their daughter Virginia was deaf. The Brushwoods were often putting together efforts to help the NAD local chapter. (Courtesy of Lee Berenson.)

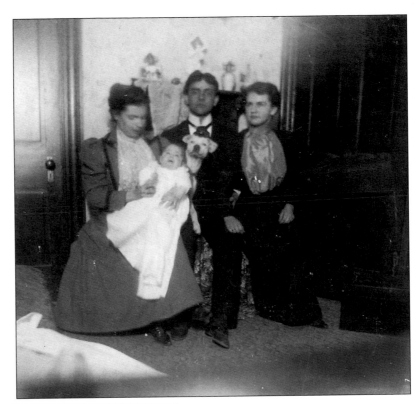

Frank A. Leitner, George's brother, attended the Kendall School and then Gallaudet. Prior to his graduation in 1890, along with George W. Veditz, he joined the Honor of the Secret Society (H.O.S.S.), a local Deaf-only fraternity that was later reestablished as the Kappa Gamma fraternity. Leitner later moved to Pittsburgh to work at the Pennsylvania School for the Deaf and married a deaf woman, Aimee Menard, of Nebraska. He was very active with the local Deaf organizations. (Courtesy of Gallaudet University Archives.)

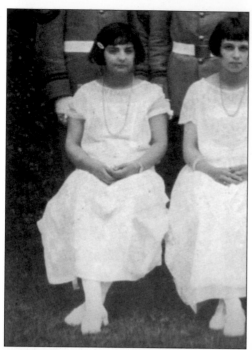

Helen B. Leitner Wriede was the deaf daughter of Helen and George Leitner. She enrolled at MSD and graduated in 1924. George Veditz once wrote about the Leitners in the *MSD Bulletin*, noting that he enjoyed Helen's letters, which he signed out loud to Colorado School for the Deaf students. Later, she married August Wriede, whom she met while he worked at MSD after school hours. This photograph was found in MSD's 1926 report. (Courtesy of MSD.)

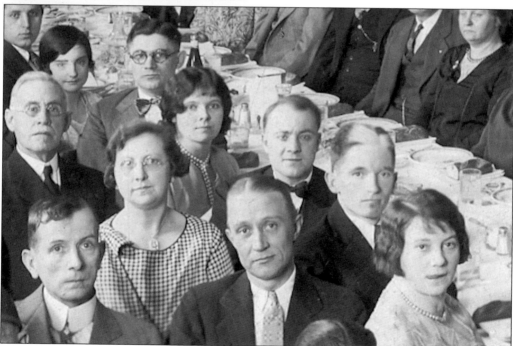

The third generation of deaf adults in the family of the early Deaf leaders is shown in this 1929 NFSD banquet photograph. Pictured from left to right are (first row) two unidentified men and Clara Wheeler McCall; (second row) unidentified woman and S. Rozelle McCall (with streaked hair); (third row) Rev. Daniel Moylan, Esther Herdtfelder, and August Herdtfelder (with black bow tie); (fourth row) Helen Leitner Wriede and August Wriede; (fifth row, obscured) and unidentified. (Courtesy of Gallaudet University Archives.)

S. Rozelle McCall, the son of Fannie Wells, was one of the prominent Deaf leaders on the East Coast. McCall attended the Kendall School and then transferred to MSD. He was known for his athleticism and charming personality. Between 1922 and 1929, McCall was enrolled at Gallaudet for a total of three years, but he did not complete his studies. Later, in 1964, he was accepted as an honorary Kappa Gamma fraternity member at Gallaudet. (Courtesy of Lee Berenson.)

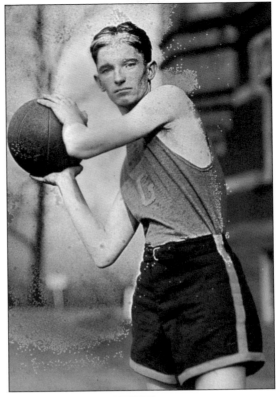

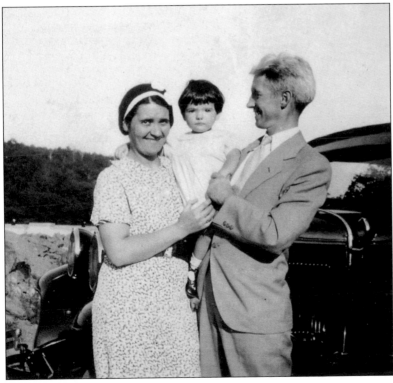

In the early 1900s, deaf drivers often had to go through obstacles to get a driver's license in Maryland. Here, from left to right, Clara, Maureen, and Rozelle McCall stand by a vehicle. Often, those who bought or traveled in their own vehicles were announced in the monthly *MSD Bulletin* distributed to the Deaf community. (Courtesy of Elinor Reese.)

Clara Wheeler McCall was born and raised in Washington, DC, and attended the Kendall School, where she met Rozelle McCall briefly before he transferred to MSD. The pair later crossed paths at Gallaudet. At a time when NFSD did not allow female members, Clara decided on February 3, 1932, to establish a secret society for the invited Deaf women that is known as F.F.F.S. The sorority is still running today, more than 80 years later. (Courtesy of Christ Deaf Church.)

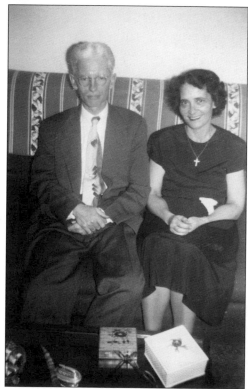

Rozelle McCall and his first wife, Clara, are seen here during their very active and happy Baltimore days. (Courtesy of Lee Berenson.)

Ruth C. Atkins graduated from the Kansas School for the Deaf and then enrolled at Gallaudet in 1915. Later, she became a member of the OWLS, which was renamed the Phi Kappa Zeta sorority. She was well liked among the students as a dean for the girls on the Kendall campus. At Kendall, she met Clara McCall, who became a longtime close friend and a godmother to McCalls' daughter Ruth "Maureen" McCall. (Courtesy of Gallaudet University Archives.)

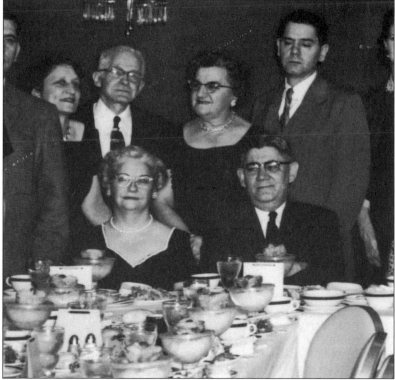

August Wriede, seen here sitting with his wife, Helen, started to work at MSD right after his graduation from NYSD at Fanwood in 1918. He was hired as a military training instructor and Scoutmaster while Ignatius Bjorlee was president of MSD. Wriede was often invited as a guest speaker at Deaf gatherings. (Courtesy of Joyce Jacobson Leitch.)

M. Carmen Slaven McCall (left) was from Arkansas and attended the Arkansas School for the Deaf, where she later became a houseparent. She then moved to Maryland to work as a houseparent at MSD. She was an active participant in local Deaf events and a devoted member of the leadership under Rozelle McCall. Through her community involvement, she met McCall (right), and they later married after he and his first wife, Clara, divorced. (Courtesy of Elinor Reese.)

# *Two*

# INDIVIDUAL DEAF LEADERS

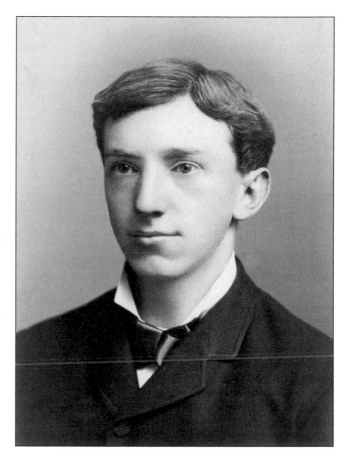

George W. Veditz was born in 1861 and came from a German immigrant family. He contracted scarlet fever when he was eight years old and enrolled at MSD at age 14. He became popular in the Deaf community in Baltimore and was involved with other early leaders like James Wells and the Leitner brothers. He graduated from Gallaudet in 1884 with honors and was inducted in the H.O.S.S. fraternity, which reestablished itself later as the Kappa Gamma fraternity. (Courtesy of Gallaudet University Archives.)

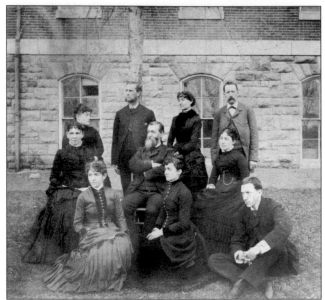

George Veditz was a young graduate of MSD in 1878. According to the *MSD Bulletin*, when his aunt traveled from Baltimore and delivered the bad news that his family could not afford to send him to Gallaudet, he was offered to work at MSD, repeating his senior year as a teacher. He was accepted to Gallaudet a year later and enrolled. Pictured from left to right are (first row) Annie Barry, Mollie Ijams, and Veditz; (second row) unidentified, Charles Grow, and Florence Doub; (third row) unidentified, school principal Charles Ely, and two unidentified fellows. (Courtesy of MSD.)

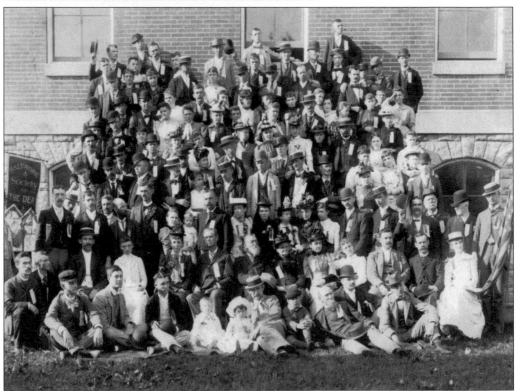

Veditz, standing in front of the banner on the far left, began his teaching position at the Colorado School for the Deaf and Blind (CSDB) in 1888. This photograph was taken around 1899 with the Baltimore Society of the Deaf, which was established in 1890. Rev. Daniel Moylan is sitting on the ground on the far left. The end of this organization is a mystery, although it celebrated its seventh anniversary in 1897, according to the October 1897 *MSD Bulletin*. (Courtesy of Christ Deaf Church.)

Daniel E. Moylan took over James Wells's place as lay reader at Grace Protestant Episcopal Church in 1891, after Wells's death. Moylan resigned after the church board declined his request to become an ordained minister. He joined the United Methodist Episcopal Church, on Eutaw Street, and then established the Methodist Deaf Church service a few years later. He became ordained and was successful in guiding an often rather large congregation of deaf worshippers for the next few decades while also participating in NAD and local activities. (Courtesy of Christ Deaf Church.)

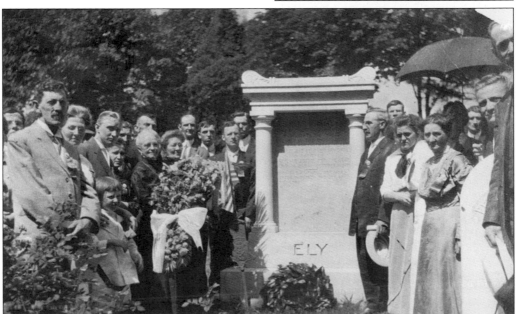

Charles Ely was the principal of MSD from 1870 to 1912 and a great friend of the Deaf community. He was favored among many, including Reverend Moylan. Ely passed away on October 1, 1912. Here, Reverend Moylan is standing on the right by the Ely headstone at Mt. Olivet Cemetery in Frederick, where the Deaf community paid their respects. (Courtesy of Christ Deaf Church.)

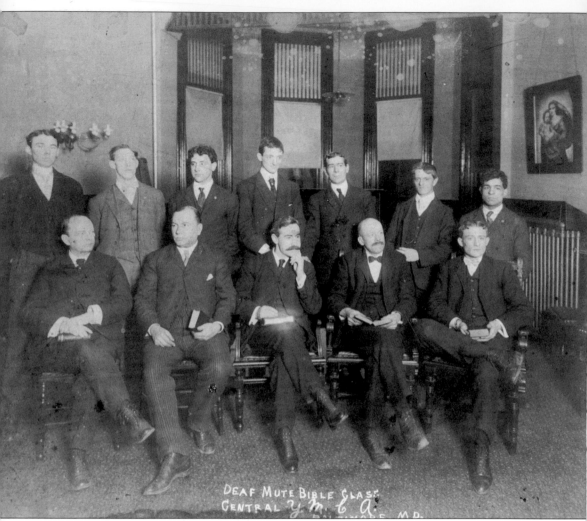

DEAF MUTE BIBLE CLASS
CENTRAL Y.M.C.A.
BALTIMORE, MD.

Deaf bible study in 1895 was held at the YMCA on Schroeder and Pierce Streets, with Reverend Moylan and Rev. John Branflick, his assistant. Identifications are based on the faded scribbling on the back of the photograph. All religions were welcomed. From left to right are (seated) George Gallion, Reverend Branflick, Reverend Moylan, unidentified, and prizefighter William Dilworth; (standing) George Brown, David Sandebeck, George "Dummy" Leitner, ? Smither, ? Heckemeyer, William Bonhoff, and Ben Bucherre. (Courtesy of Christ Deaf Church.)

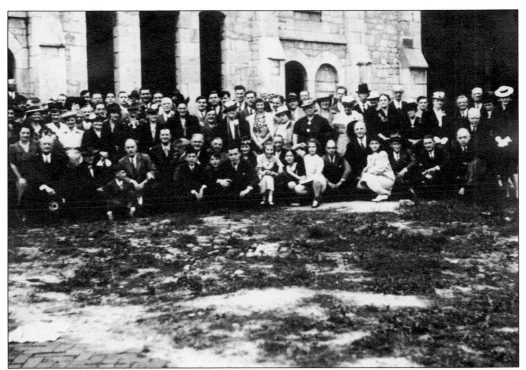

There were 140 deaf worshippers mourning great Deaf leader Rev. Daniel Moylan after his death. This photograph is from the memorial service, held shortly after his death on March 31, 1943, with Gov. Herbert R. O'Conor and Baltimore mayor T.R. McKeldon in attendance. The collection during the church service honoring Moylan was $72.75, which was one of the highest collections at that time. (Courtesy of Christ Deaf Church.)

Percival Hall, the president of Gallaudet, was known to establish many new things, including the Kappa Gamma fraternity. He wrote this sympathy letter mourning the death of Moylan in 1943. Moylan's death shattered the East Coast's Deaf community, as the death of George Veditz had in 1937. (Courtesy of Christ Deaf Church.)

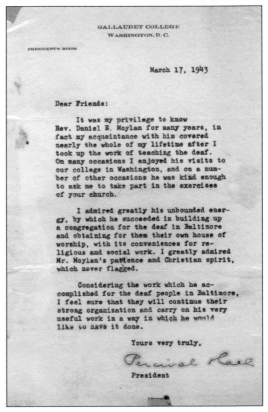

GALLAUDET COLLEGE
WASHINGTON, D. C.

PRESIDENT'S ROOM

March 17, 1943

Dear Friends:

It was my privilege to know Rev. Daniel E. Moylan for many years, in fact my acquaintance with him covered nearly the whole of my lifetime after I took up the work of teaching the deaf. On many occasions I enjoyed his visits to our college in Washington, and on a number of other occasions he was kind enough to ask me to take part in the exercises of your church.

I admired greatly his unbounded energy, by which he succeeded in building up a congregation for the deaf in Baltimore and obtaining for them their own house of worship, with its conveniences for religious and social work. I greatly admired Mr. Moylan's patience and Christian spirit, which never flagged.

Considering the work which he accomplished for the deaf people in Baltimore, I feel sure that they will continue their strong organization and carry on his very useful work in a way in which he would like to have it done.

Yours very truly,

Percival Hall

President

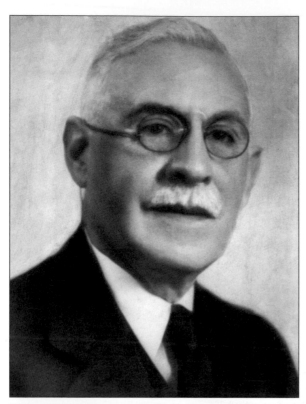

This is the last known formal photograph of Rev. Daniel E. Moylan, taken before his death in 1943. (Courtesy of Christ Deaf Church.)

The photograph was taken in April 1901, with young Moylan on the far left with a delighted and cheerful group. (Courtesy of Christ Deaf Church.)

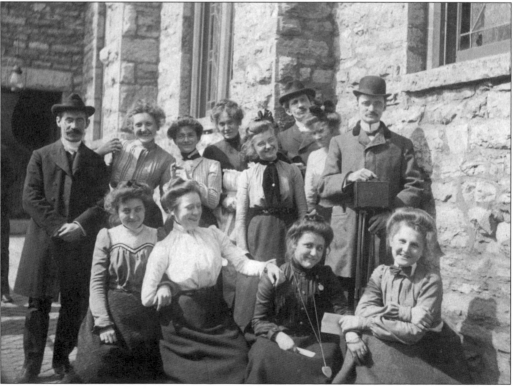

Jerome Horsey (front row, second from left) and Charles Waters (second from right) determined to continue the Whatcoat Deaf Mission, founded in 1905. It was the earliest Black Deaf church mission group Reverend Moylan officially established. After Moylan's death, Horsey and Waters took over, with Horsey giving sermons at different homes until Rev. Louis Foxwell Sr. helped them find a location. Ellsworth Bouyer is standing behind Horsey and Waters. (Courtesy of Zelephiene Jennings Jones.)

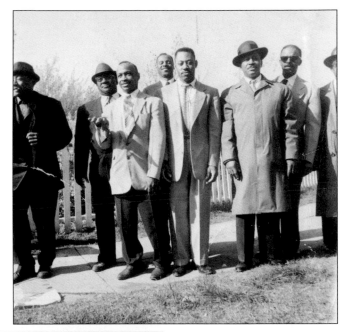

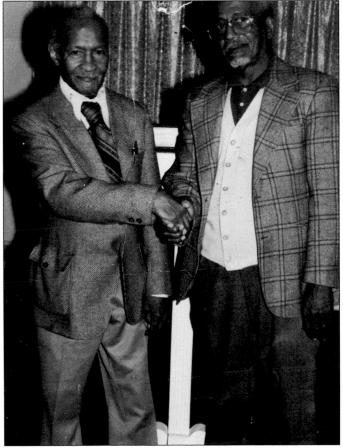

Horsey and Waters, seen here in the 1960s, had great pride in their accomplishments and the recognition that the Whatcoat Deaf Mission received. Later, Reverend Foxwell helped black deaf worshippers blend in with all worshippers, ceasing the segregation after 1957. The new congregation still often preferred when the Black Deaf congregation cooked the delicious food after services. Zelephiene Jennings remembers that many people enjoyed the food her family cooked. (Courtesy of Christ Deaf Church.)

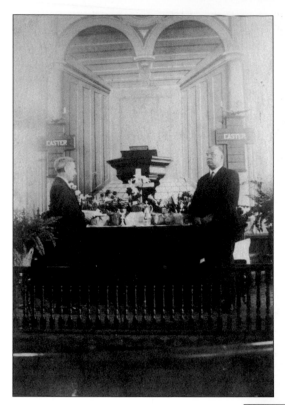

Reverend Moylan and his assistant, Rev. John A. Branflick, gave Easter service the day this photograph was taken. Both were also very active with other local Deaf organizations, including serving the Whatcoat Deaf Mission at a separate Black Deaf congregation. Branflick was devoted to George Veditz's founding organization, the Maryland Association of the Deaf (MAD), and the Baltimore Society of the Deaf. Moylan was involved with the National Association of the Deaf (NAD). (Courtesy of Christ Deaf Church.)

Deaf couple Donnell and Mary Wilson dressed up in their best for a special Easter Sunday church service in 1970. Donnell was a meat cutter for the Dukeland Packing Company. That same year, he was honored for never missing a day of work and never being late for work during the six years he had worked for the company, according to the *Evening Sun*. (Courtesy of Christ Deaf Church.)

Ray M. Kauffman, standing on the far right behind his wife, began his leadership in the early 1920s with Rozelle McCall. He was often seen on the committees, chairing many events and being on the board for the Christ Deaf Church. Kauffman was the father of the NFSD Baltimore Chapter No. 47. James B. Foxwell, Rev. Louis Foxwell Sr.'s deaf father, is standing on the left next to Kauffman. (Courtesy of Christ Deaf Church.)

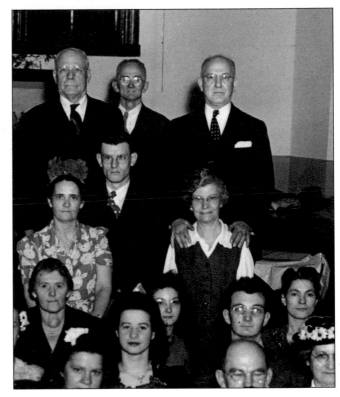

Young Sheldon Arthur Blumenthal was an Eagle Scout, as seen in this photograph. He became one of the prominent Deaf leaders in the Baltimore community, along with his wife, Betsy Seidenman Blumenthal. They led the Jewish Deaf Society, the NFSD Baltimore Chapter, and the Silent Oriole Club (SOC). This photograph was retrieved from the June 1936 *MSD Bulletin* in Lois Markel's possession. (Courtesy of MSD archives.)

Sheldon and Betsy Blumenthal are seen here in 1947. Sheldon was involved in the National Congress of Jewish Deaf and served as the president of the Baltimore chapter, known as the Jewish Deaf Society. Betsy was one of three founders of the Silent Clover Society, a Deaf women's club. Together, they raised two deaf daughters, Terry Ann and Arlene. (Courtesy of Arlene Blumenthal Kelly.)

# *Three*

# RELIGION

Rev. Daniel E. Moylan is seen here
around 1942. During his last years,
after his wife's death, he lived in
the church. He was a legend in
the Christ Deaf Church for years.
(Courtesy of Christ Deaf Church.)

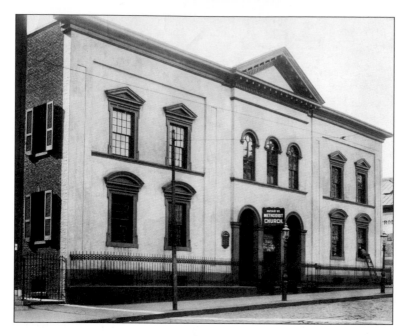

Christ Deaf Church began on Eutaw Street, where Reverend Moylan began his ministry a few years after 1898. Soon, most of the congregation of the Episcopal church followed him after he converted his religion and moved to another location. This was the first building. Later, the worshippers moved to a few more churches until they had their own building. (Courtesy of Christ Deaf Church.)

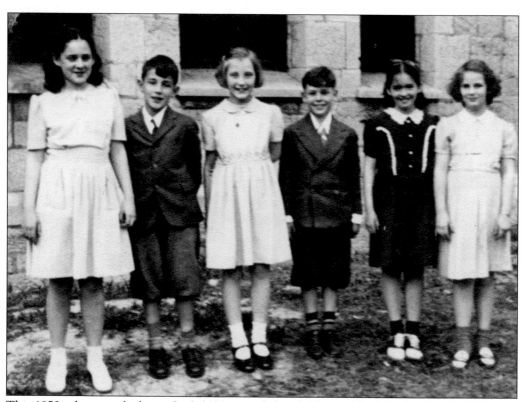

This 1950s photograph shows deaf children and the children of deaf worshippers smiling with pride at the camera. A young Maureen McCall is second from the right. (Courtesy of Christ Deaf Church.)

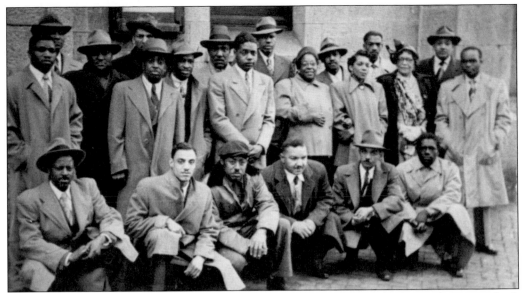

The Whatcoat Deaf Mission began its service at the Whatcoat Church, on Lovely Lane, which was managed by Reverend Moylan. The people in this photograph were identified, in no particular order, as Clarence Barnes, Randolph Green, John Dallard, William Richardson, Perry Chase, Edward Green, Leslie Pitt Sr., Jerome Horsey, William Johnson, George Washington, Robert Davis, George Luckey, William Giles, Edward Minster, Carroll Johnson, Herbert Childress, Mary Shields, Carrie Johnson, and Willie Gerbert. (Courtesy of Christ Deaf Church.)

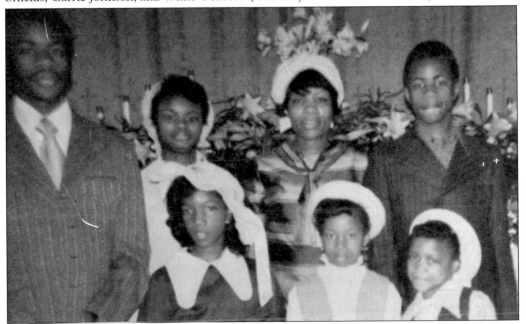

On Easter Sunday in 1969, Annie Mae Peoples-Jennings (second row, second from right) made sure all of her deaf children were dressed in their best Sunday outfits. They are, from left to right, (first row, all hearing) Diane, Brenda, and Cynthia; (second row, all Deaf) Pedro, Zelephiene, Annie Mae, and Norman Jr. Their father, Norman Sr., often had to work on Sundays, but the family still went to the church regularly. (Courtesy of Zelephiene Jennings Jones.)

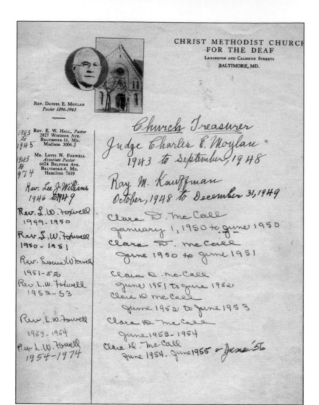

Shown in this photograph is an old church document that every treasurer signed and wrote their names and years on. Clara McCall was a frequent treasurer for the Christ Deaf Church. (Courtesy of Christ Deaf Church.)

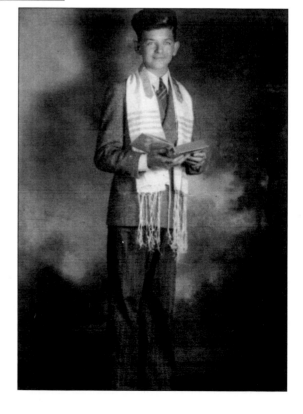

Eugene H. Rubenstein was born deaf and grew up using American Sign Language (ASL) only outside of the house, except for with one sister who learned to sign. He graduated in 1947 from MSD. He is seen here at age 13 getting his bar mitzvah, which he received without an interpreter. He just read what the Rabbi requested him to read in order to complete the ceremony. (Courtesy of Eugene H. Rubinstein.)

Manuel "Manny" Rubinstein became hard of hearing at three years old due to damaged nerves in both ears. His mother decided to place him at the William S. Baer School, instead of at MSD with his deaf brother Eugene. Manny grew up oral and enrolled in the local high school as the only hard-of-hearing student without an interpreter. At his bar mitzvah at age 13, he read the words orally to complete the ceremony. (Courtesy of Manny Rubinstein.)

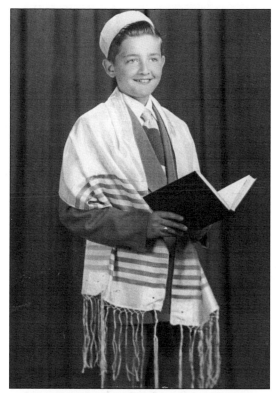

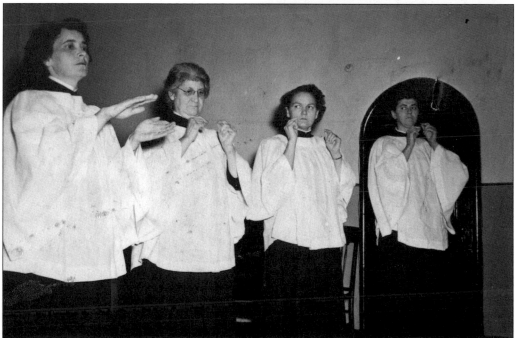

Clara McCall guided the ladies choir in sign language. This photograph from around 1948 shows, from left to right, McCall, choir director Margaret Sandebeck, Helen Hook, and Edna Watkins. (Courtesy of Christ Deaf Church.)

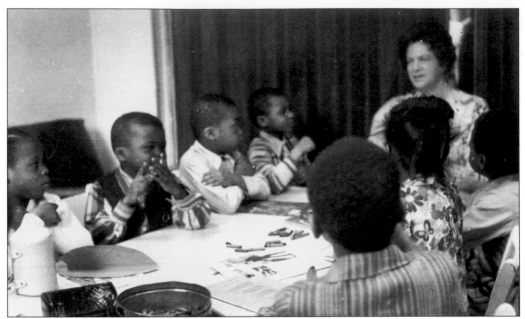

In the 1960s, Ruth Foxwell (far right) taught Sunday school for children in sign language. Ruth was married to the late Rev. Louis Foxwell Sr., who served the Christ Deaf Church. She was a longtime sign language instructor at the St. Mary's Seminary. Later, after her first husband's death, she married Harvey Farris and resided in Chester, Florida, until her death in 1998. (Courtesy of Christ Deaf Church.)

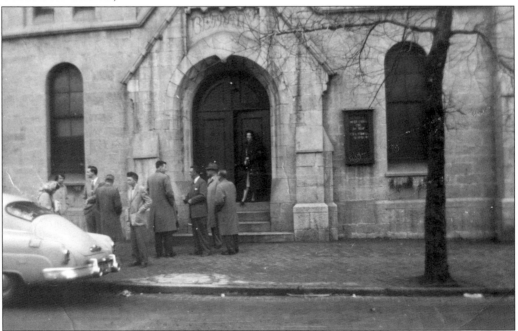

This photograph, taken at the Calhoun Street Church, shows Youth Silents Club (YSC) men about ready to leave to play a game against another basketball team. The men were gathered outside along with Ruth Foxwell, Reverend Foxwell's wife, seen on the front steps. (Courtesy of Christ Deaf Church.)

The first-annual basketball banquet for the Inter-Eastern States Basketball League of the Deaf was on Saturday, April 19, 1947. In its second year, the league became known as the Southeastern Athletic Association of the Deaf (SEAAD). Christ Deaf Church was proud of their YSC men's and women's teams, which were coached by motivated coaches like Clara McCall, James Foxwell (Reverend Foxwell's father), Fleet Bowman, and Bill Harris. Reverend Foxwell was the athletic director. (Courtesy of Christ Deaf Church.)

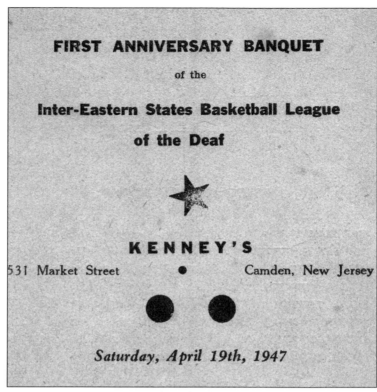

**FIRST ANNIVERSARY BANQUET**

of the

**Inter-Eastern States Basketball League**

**of the Deaf**

★

**K E N N E Y ' S**

531 Market Street • Camden, New Jersey

*Saturday, April 19th, 1947*

This service was held in the late 1950s at the only church service for the Deaf, possibly on Loch Raven Boulevard in Baltimore. After 1957, black deaf worshippers joined white deaf worshippers after Reverend Foxwell encouraged the separate services to become one. (Courtesy of Christ Deaf Church.)

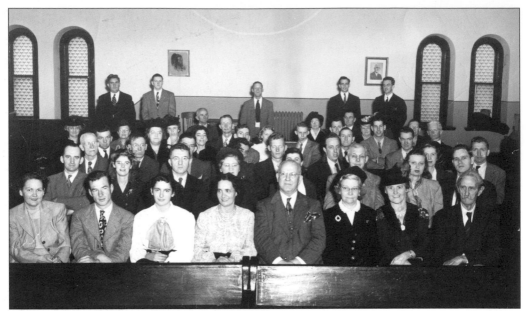

This sermon was held on a Sunday in the late 1940s at the Calhoun Street Church. In the front row, third and fourth from the left, are Maureen and Clara McCall. Rozelle McCall is sitting in the far back right corner, and Rev. Louis Foxwell Sr. is standing in the back on the far right. John Hook, who was an elder, was often involved; he is standing second from the left. (Courtesy of Christ Deaf Church.)

At the time of his death in 1933, Philip Gehb, the deaf brother of Reverend Moylan's wife, Ollie Lincithium, donated over $3,000 to Christ Deaf Church for a good use. Some of the money went toward painting supplies for the basement, where the Whatcoat Deaf Mission was first located. Later, the church decided to name the social fellowship hall Gehb Hall after him. Gehb attended MSD with the Lincithiums and the Moylans. (Courtesy of Christ Deaf Church.)

This church, a formerly beautiful architectural church on Orchard Street, was the second church managed by Reverend Moylan, from 1917 to 1927. Later, it was closed up with the boards shown in this photograph. (Courtesy of Christ Deaf Church.)

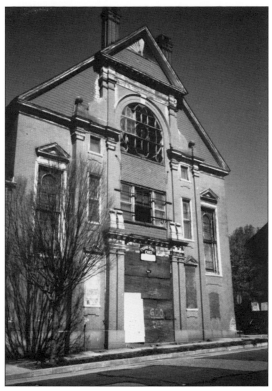

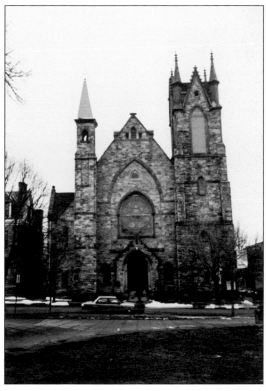

The Methodist Deaf Church moved to this bigger and fancier church building, known as the Metropolitan Church, on Lanvale and Carrollton Streets, and operated there from 1927 to the early 1940s. (Courtesy of Christ Deaf Church.)

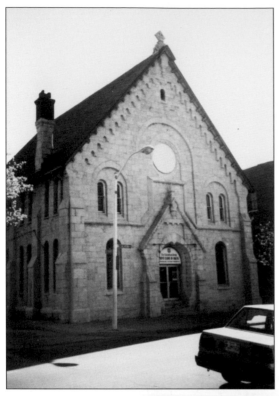

From the 1940s to 1956, the Calhoun Street Church was the only church where sports began with the YSC men and women. After Reverend Moylan's death, Rev. Louis Foxwell Sr., a child of deaf parents, took over and served for a long period of time as the reverend and athletic director. According to one longtime deaf worshipper, some worshippers considered Reverend Foxwell a surrogate father. (Courtesy of Christ Deaf Church.)

An unidentified young woman signs while other young worshippers look on during a Sunday school session in the 1950s. (Courtesy of Christ Deaf Church.)

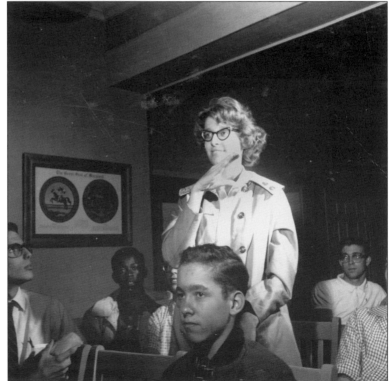

*Four*

# EDUCATION

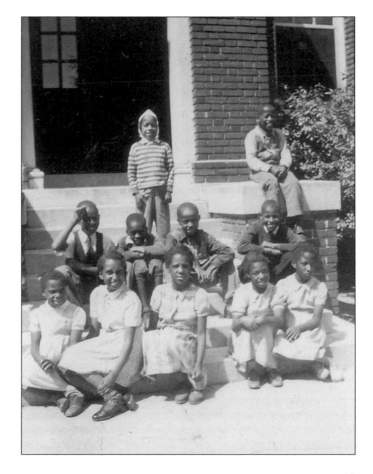

Students pose for a photograph outdoors at the Maryland School for Deaf Colored Youths at Overlea. They were identified by Zelephiene Jennings Jones as, from left to right, (first row) Mary Gilbert, Dorothy Barnes, Carrie Spivey, Nettie Rasin, and Josa Robinson; (second row) two unidentified students, Larry Riffin, and Ellsworth Bouyer; (third row) Norman Robinson and Herman Ross. (Courtesy of MSB archives.)

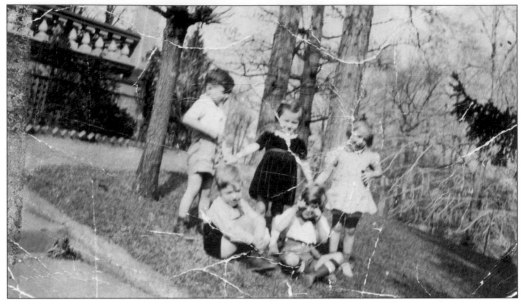

There were several five-year-old deaf students enrolled at the William S. Baer School, which did not allow any sign language. This 1940s photograph shows students enjoying the outdoors. They are, in no particular order, Harriet Grossblatt, Michael Downey, Leo Henry, Tomas ?, and an unidentified child. (Courtesy of Harriet Grossblatt Greenberg.)

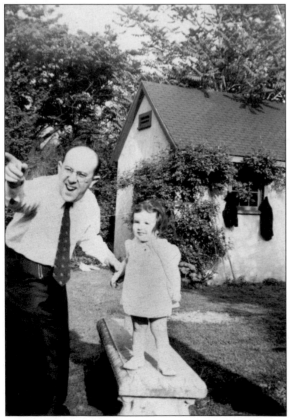

Deborah Meranski's father, Dr. Israel "Pete" Meranski, tries to communicate with her by pointing to a bird in this image. Dr. Meranski, a Baltimore pediatrician, treated a baby named Donald Leitch who later went to MSD. The Meranskis, who were Jewish, had put little Deborah in a Catholic school for the Deaf because there were no other prekindergarten schools for deaf students in Baltimore. She transferred to the William S. Baer School at the age of five. (Courtesy of Deborah Meranski Blumenson.)

Maureen McCall, a hearing child of deaf parents, attended regular schools. However, sign language was her primary language. She attended Christ Deaf Church, surrounded by deaf worshippers learning to communicate in sign language. (Courtesy of Elinor Reese.)

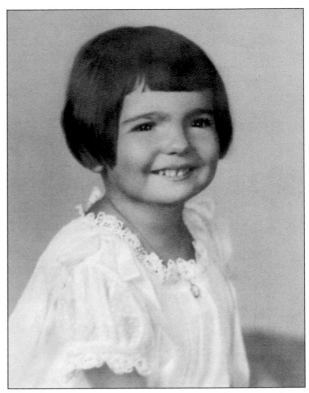

Harriet Grossblatt attended the William S. Baer School and learned the oral method. She was not permitted to learn sign language in school or at home. She attended Mergenthaler High School as the only deaf student without an interpreter. She remembered vividly how overwhelmed she was trying to learn with these difficulties. She is seen here as a member of the senior class of 1957. (Courtesy of Harriet Grossblatt Greenberg.)

Maryland School for Deaf Colored Youths resident principal Henry J. Stegemerten (second from right) poses with students (from left to right) George Luckey, Herbert Robinson, and William Johnson. Stegemerten was the resident principal from 1919 until he retired in 1956. (Courtesy of Zelephiene Jennings Jones.)

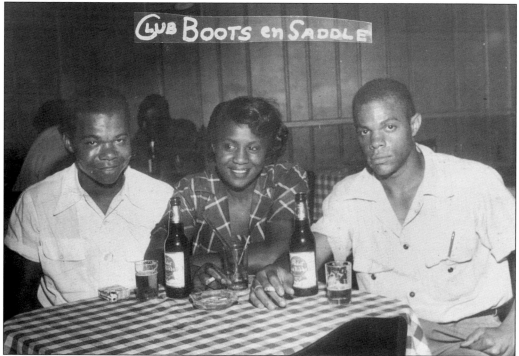

Students are seen here waiting in the Greyhound lounge for their bus. Greyhound bus service was a popular independent transportation method for students to travel to schools in both Overlea and Frederick from Baltimore beginning around 1950. Seated from left to right are Geno Jenkins, Catherine Snell, and Herbert Robinson. (Courtesy of Zelephiene Jennings Jones.)

William Barry was president of the MSD board, Baltimore Deaf Community liaison, and president of the Fire Insurance Company in Baltimore until his death in 1890. He was a close friend of the Wells family and had an only daughter, Annie, who was deaf. The Wells and Leitner families went on to name children in honor of him and Annie. A few years after he died, a bust in his honor was set on the MSD campus. (Courtesy of MSD.)

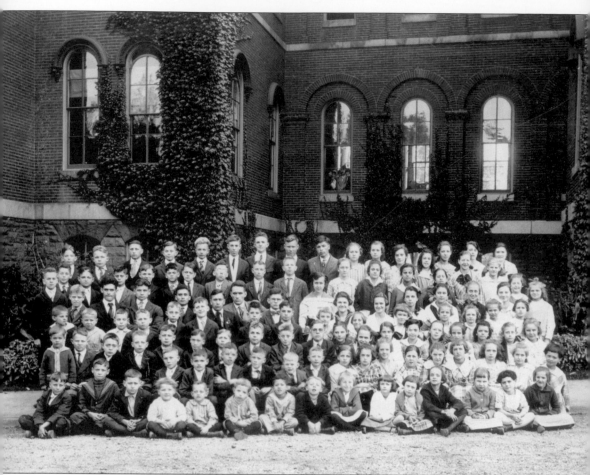

This 1918 photograph shows pupils posing at the beginning of the school year at MSD in Frederick. Many of the students came from Baltimore. According to the 24th biennial report of the Maryland School for the Deaf, dated December 2, 1926, the largest number of pupils from Baltimore, 97, attended the school in 1923–1924. From 1924 to 1926, there were 88. Rozelle McCall is on the far left in the back row, and his cousin Helen Leitner Wriede is sitting in the third row, sixth from the right. (Courtesy of MSD.)

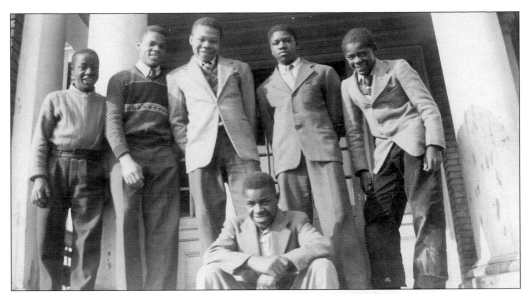

This 1950s photograph shows a group of young men standing behind the boys' dormitory at the Maryland School for Deaf Colored Youths (Overlea). They are, from left to right, George Brown, Herbert Robinson, Geno Jenkins, Donald Chase, Franklin Mason, and William Bell. (Courtesy of Zelephiene Jennings Jones.)

Betwen 1953 and 1956, Milbert Jones attended Overlea. He was one of the 13 black deaf students to be sent to MSD in 1956. He traveled from the Eastern Shore by ferry then by bus from Baltimore to Frederick. There was no bridge from the Eastern Shore and the mainland until 1964. (Courtesy of Zelephiene Jennings Jones.)

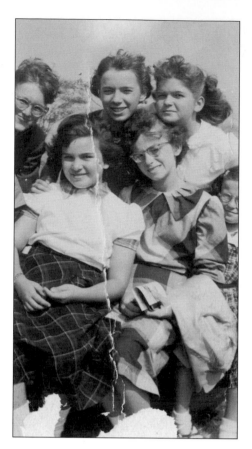

After school hours, when teachers were not around, students at the William S. Baer School communicated in both oral and sign language. This photograph shows, in no particular order, Billy Hauer, Judy ?, Diana ?, Harriet ?, and Peggy ?. Harriet Grossblatt is in the top center. (Courtesy of Harriet Grossblatt Greenberg.)

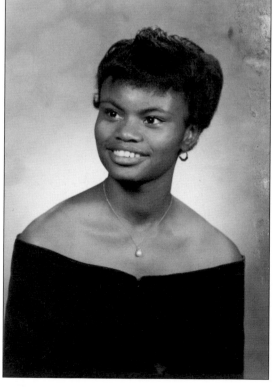

Zelephiene Jennings, who came from a deaf family, graduated in 1974 from MSD. She then enrolled at Gallaudet, where she earned undergraduate and master's degrees. She worked at MSD in the vocational department. Growing up, her deaf family loved cooking soul food, which was very popular at Christ Deaf Church gatherings. She kept the passion for food and taught a cooking class at MSD. (Courtesy of Zelephiene Jennings Jones.)

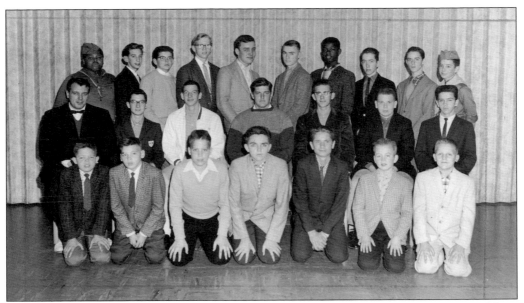

MSD's after-school activities included the Boy Scouts. As identified by Zellie Jones, pictured from left to right in this early-1960s photograph are (first row) A. Wright, C. Maxwell, N. Gehman, J. Ennis, D. Aydelotte, D. Seager, and P. Kappus; (second row) Scoutmaster Mr. Barrett, A. Richey, S. Butts, L. Saunders, J. Ritter, A. Amberg, and V. Mainon; (third row) D. Adams, C. Coffey, L. Reedy, D. Hahn, M. Brown, L. Bowie, Milbert Jones, L. Allen, P. Morris, and M. Childs. (Courtesy of Milbert and Zelephiene Jones.)

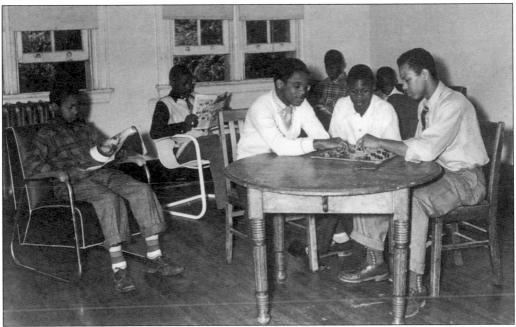

The boys at Overlea play chess after school hours in the boys' dormitory. At the table on the right, Zelephiene Jones identified, from left to right, Robert Lucas, Norman Jennings, and Phillip Armstrong. The boys sitting on the left and in the background are unidentified. (Courtesy of MSB.)

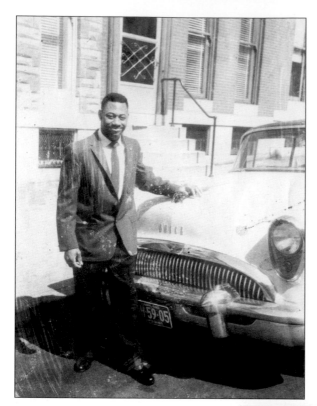

Charles Christian proudly purchased this yellow convertible in the early 1960s. He drove all of the deaf Jennings children to MSD every weekend from Westport, Baltimore. Despite living in Baltimore all his life, Christian attended the Virginia School for the Deaf instead of MSD, commuting by railroad. (Courtesy of Zelephiene Jennings Jones.)

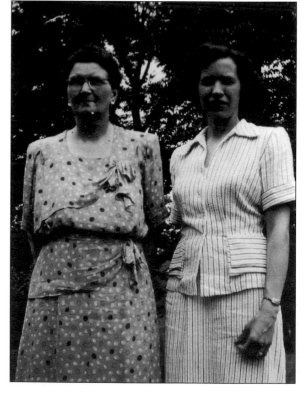

This photograph shows two unidentified teachers from the William S. Baer School. This was before the total communication was begun in 1972 by Reverend Louis Foxwell Sr. On top of teaching regular courses, the school also taught money management through the school bank. One student left his small savings in the bank and forgot all about it until the bank reached his father after his Gallaudet graduation to send him the contents of the account, which had grown with interest. (Courtesy of Simon J. Carmel.)

This photograph was taken in the 1930s. Deaf students under age five attended St. Francis Xavier's Catholic School in Baltimore County until they could be enrolled in a kindergarten class elsewhere. Children of all religions were accepted there. Edwin Markel is second from the left. (Courtesy of Lois Markel.)

George H. Faupel entered Gallaudet from MSD. He became a Kappa Gamma fraternity member and earned a bachelor's degree in 1907. After his graduation, he taught one semester at Overlea and then transferred to MSD in Frederick. He was a teacher, artist, and active leader in the community. His deaf daughter Doris inherited his leadership skills after her MSD graduation. His sketch art appeared sometimes in the *MSD Bulletin* and in the *American* in Baltimore. (Courtesy of Christ Deaf Church.)

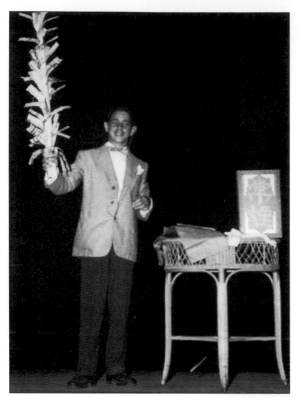

Simon Carmel began learning his first magic tricks at around four years old from his father. He attended the William Baer School, and by age 15 he had become a skilled entertainer at parties, banquets, and hospitals. His mother acted as his volunteer "chauffeur" and "secretary," driving him and receiving phone calls for him to prepare the magic shows all over the Baltimore area. He remembered performing at least five times on the stage at the Baer School. (Courtesy of Simon J. Carmel.)

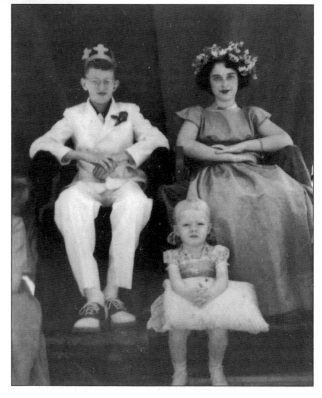

The William S. Baer School celebrated May Day, as did many other local schools. This 1950s photograph shows Billy Hauer (left), who was elected king, and a girl tentatively identified as Sheila M., a hearing-disabled student who was elected as the May queen. The little girl in front was also deaf and is believed to have had another deaf sibling named Russell, who attended the school with her. (Courtesy of Simon J. Carmel.)

Young deaf students from the William S. Baer School play games outside during recess. Little Simon Carmel is standing in the front middle. This photograph was taken in the 1950s. (Courtesy of Simon J. Carmel.)

Young Joanna Sturgis is seen here in the MSD reunion souvenir booklet in 1938. She became Joanna Harris in her married days. (Courtesy of Lois Markel.)

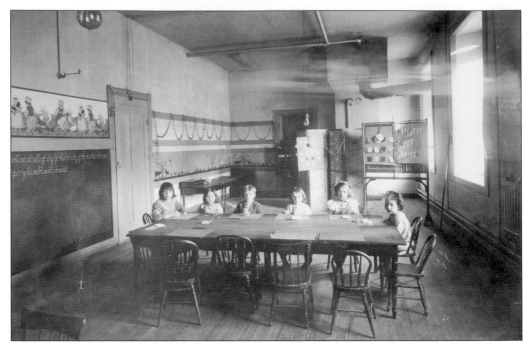

A high number of Baltimore students traveled to MSD to attend school and live on the campus. During that time, they had unique classes, including cosmetology and shoemaking. This photograph was taken in the early 1900s. (Courtesy of MSD.)

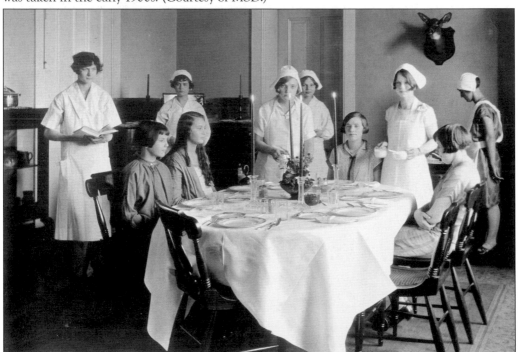

The cooking class learned to serve promptly with table manners at MSD in the early 1900s. Sitting on the far left is believed to be Helen Barry Leitner, the daughter of Helen and George Leitner and the future wife of August Wriede. (Courtesy of MSD.)

# *Five*

# ORGANIZATIONS

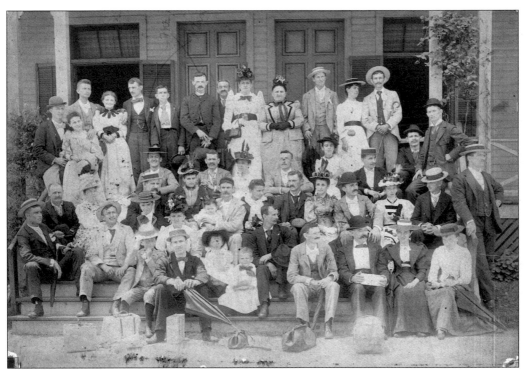

MAD members gather for a portrait together on July 9, 1893, on their usual leisure trip to Bay Ridge, across the Chesapeake Bay from the coast. Note the nice carrying bags on the ground in front of the group. (Courtesy of Christ Deaf Church.)

The Jewish Deaf Society was a popular organization, with members often getting together for Passover seders, Hanukkah parties, and bingo games. Among the people in this early-1960s photograph are Benjamin Myerovitz (standing, 10th from left), Eugene Rubinstein (next to him on the right), Nancy Tannebaum Goldberg (seated, fourth from right), Louis Goldberg (standing, fifth from right), and Goldberg's wife, Harriet Grossblatt Greenberg (standing, second from left). (Courtesy of Harriet and Louis Greenberg.)

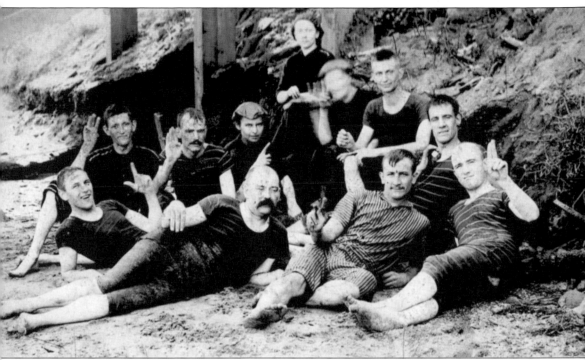

MAD members and officers posed for this photograph on August 20, 1893, while on a leisure trip on a hot day at the beach. They rode the ferry from the Maryland mainland. Note that some have used their last name initials in sign language. They are, from left to right, (first row) unidentified; William McElroy, second vice president; unidentified; and Robert E. Underwood, treasurer; (second row) ? Werner; John A. Branflick, president; and two unidentified members; (third row) unidentified. (Courtesy of Christ Deaf Church.)

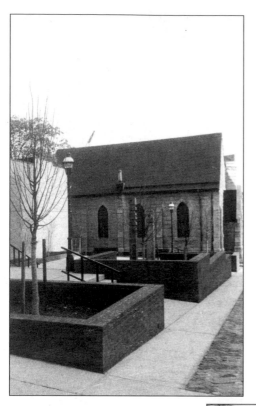

This 1975 photograph shows what was known as the Ebenezer Primitive Old School and Baptist Church, on Calvert Street near Madison Street. A known site for the Baltimore Society of the Deaf, it was established in 1890. The last known year of its association with the organization was 1897, when it was mentioned in the *MSD Bulletin*. (Courtesy of Christ Deaf Church.)

Druid Hill Park was a large popular park with beautiful scenery. The Deaf community often used it for events from the late 1800s through most of the 1900s. Annual festivities for the Deaf were started at the park by James Wells and William Barry in 1886. The park was also used for the earliest celebration for the Grace Church for the Deaf, in 1883. (Courtesy of Christ Deaf Church.)

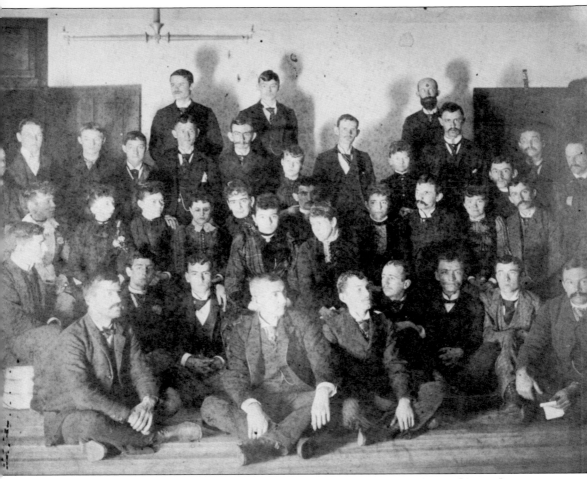

The photograph was taken in the late 1800s at a New Year's Eve party. Young George Leitner is seated on the floor second from left. Frank, George's deaf brother, is sitting in the middle of the middle row, seventh from left behind two women, and Annie Barry is sitting next to Frank on the right. A note on the back reads, "using flash camera in the dark." (Courtesy of Christ Deaf Church.)

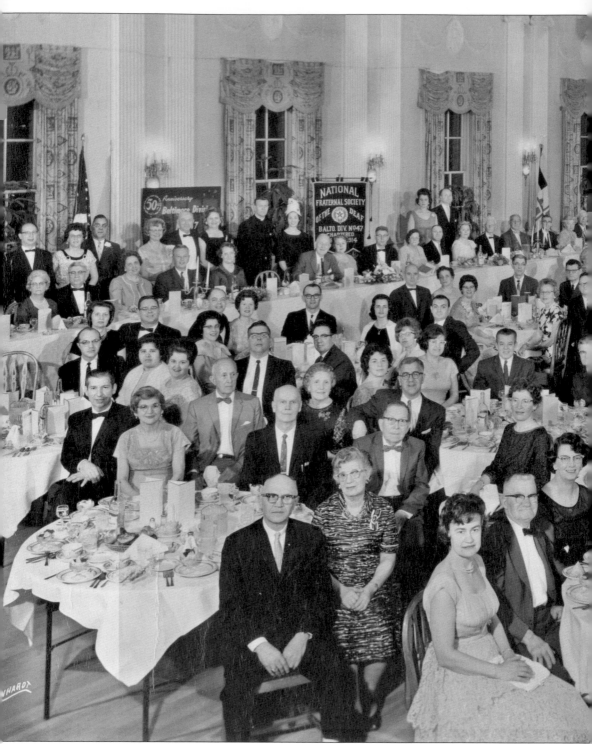

The NFSD Baltimore Chapter celebrated its 50th anniversary with a banquet in Baltimore. Helen and August Wriede are sitting at the long table in the back, first and second on the far left. From 11th to 14th from the left at the same table are Carmen and Rozelle McCall and Ray

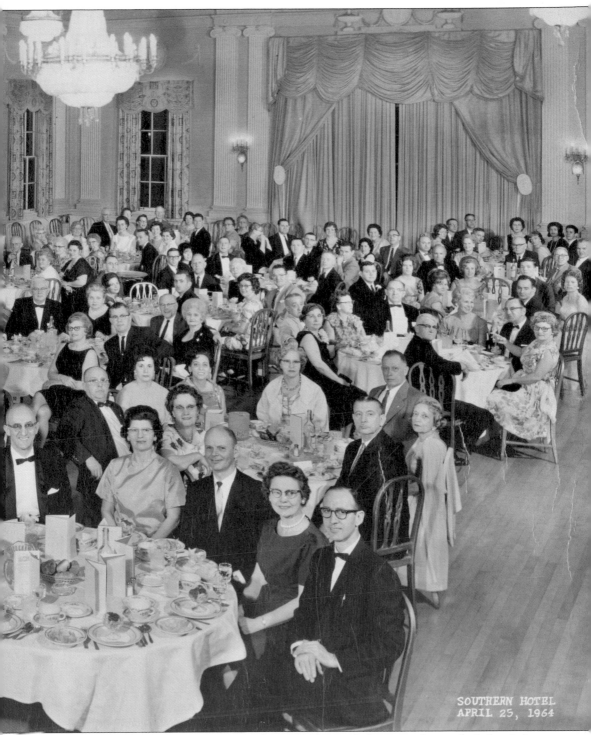

SOUTHERN HOTEL
APRIL 25, 1964

and Mrs. Kauffman. Sheldon and Betsy Sidenman Blumenthal are standing right behind the Wriedes. Sitting at the long table sixth and seventh from left are Judge Charles Moylan and his wife. (Courtesy of Gallaudet University Archives.)

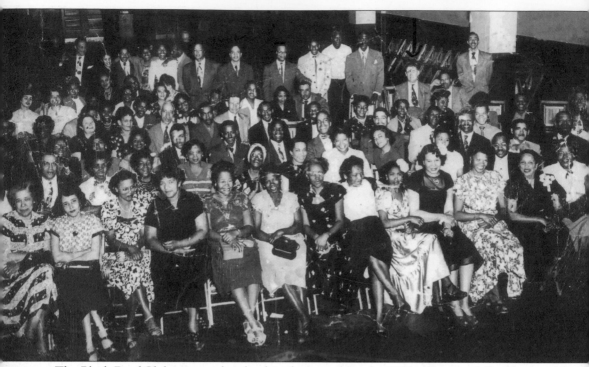

The Black Deaf Club got together for this photograph in the 1950s. They are full of smiles and all dressed up for the camera. (Courtesy of Zelephiene Jennings Jones.)

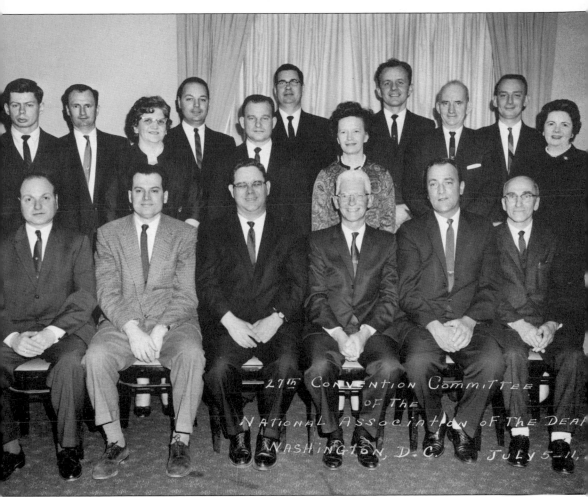

The NAD's 27th convention was held in Washington, DC, on July 5–11, 1964, with the Virginia, Maryland, and District of Columbia chapters working together. The committee members in this photograph are, from left to right, (first row) Alexander Fleischman, unidentified, James Barrack, Rozelle McCall (chairman), and two unidentified members; (second row) three unidentified members, Alfred Sonnenstrahl (McCall's assistant), Frank Turk, ? Baraty, unidentified, Roger Scott, Charles Knowles, Donald Leitch, and unidentified. After the conference, McCall was inducted as an honorary member of the Kappa Gamma fraternity. That same year, NAD granted female members the right to vote; the following year, the black deaf were allowed to become members. (Courtesy of Joyce Jacobson Leitch.)

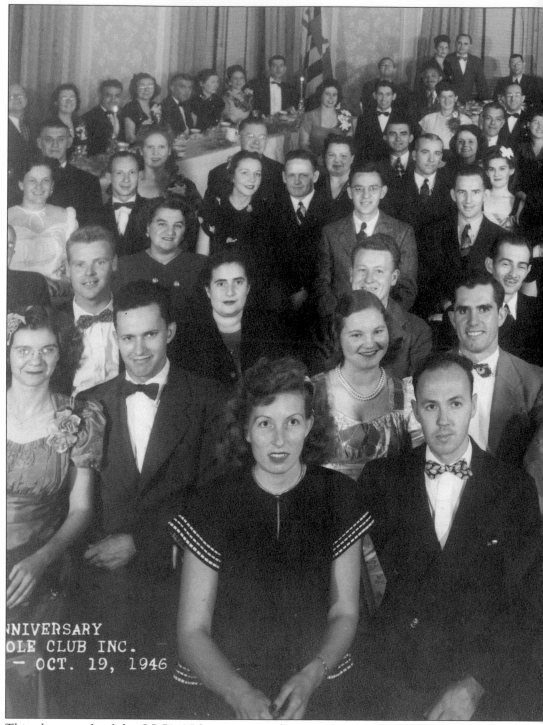

NIVERSARY
OLE CLUB INC.
— OCT. 19, 1946

This photograph of the SOC's 25th-anniversary banquet, held on October 19, 1946, shows celebrants in their fancy clothes. Lois and Edwin Markel are seated behind the first row in the middle. Betsy Seidenman Blumenthal is seated on the far left in a pretty white blouse next to her husband, Sheldon. Betsy taught sign language at the Baltimore Hebrew Congregation from

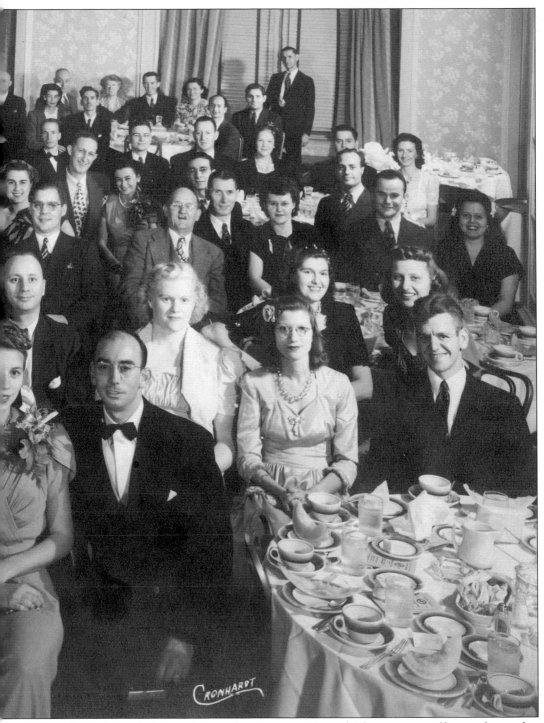

1972 to 1981. Deborah Meranski's mother, Jeanette Meranski, became one of her students after she realized she wanted to be able to communicate with her deaf grandchildren. (Courtesy of Lois Markel.)

Reverend Moylan was not only an active pastor to the Deaf community, he was also a local representative for the state of Maryland with the National Association of the Deaf (NAD). In 1910, he took a trip to the convention in Colorado Springs as a delegate. He is seen here on the far right at the top, while delegates took a break to visit Mount Manitou Park and ride on the Manitou Incline. (Courtesy of Christ Deaf Church.)

The F.F.F.S. got together and almost never missed their monthly meeting. This photograph was taken in the late 1960s and shows, as identified by Lois Markel and Arlene Blumenthal Kelly, from left to right, (first row) Gracie Watson and Betsy Blumenthal; (second row) Edna Stanley, unidentified, Gladys Leitch, Nettie Elliott, Irma Reeb, Olivia Kelly, Joanna Harris, unidentified, and Doris Knowles; (third row) Ms. Stanley, Rita Bowman, Cecelia Barrack, Dorothy Hathaway, Doris Schwartz, Sue Everhart, Annie Waters, Evelyn Amberg, unidentified, and Helen Hook. (Courtesy of Joyce Jacobson Leitch.)

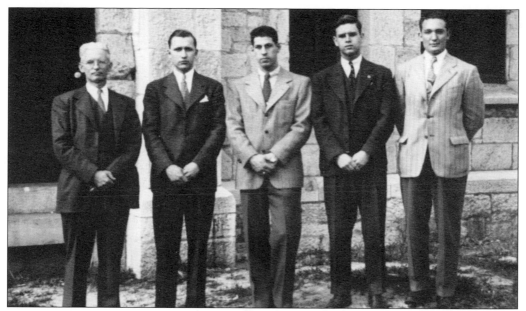

A few members devoted their time to be officers for the Gehb Social Fellowship Hall. Seen here from left to right are Rozelle McCall, Conrad Och, unidentified, James Barrack, and unidentified. (Courtesy of Christ Deaf Church.)

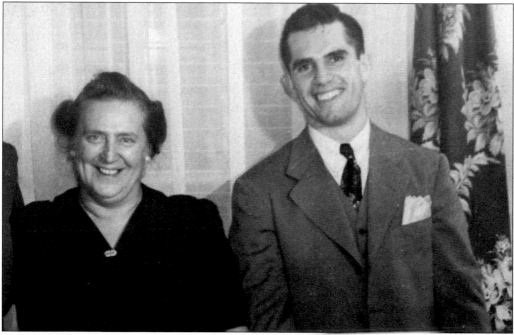

Gladys Leitch and Edwin Markel often attended meetings for the York Association of the Deaf (YAD) in York, Pennsylvania, where the Leitner family was also from before they moved to Parkton, Maryland, where the Leitner children were born. Markel grew up on a farm in Pennsylvania before meeting his future wife, Lois, and moving to Sykesville, Maryland, where he built a customized home for his family, including his five deaf sons. Living in Maryland did not stop the Markels from attending YAD events. (Courtesy of Lois Markel.)

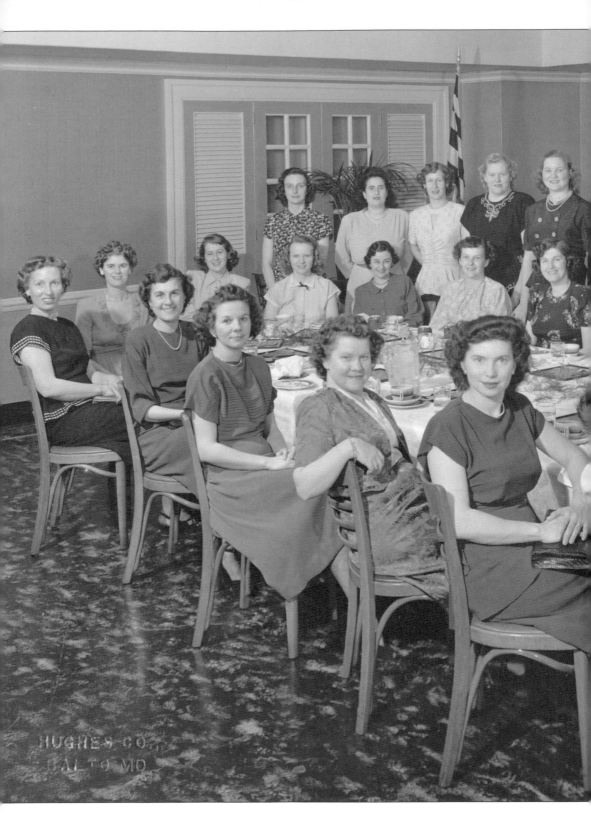

Another club was the Silent Clover Society, which was for younger ladies, while the F.F.F.S. was for older ladies. The club was founded in 1944 by S. Doris Knowles, Betsy Blumenthal, and Nancy Goldberg. Lois Markel and Arlene Blumenthal Kelly identified these members as (seated, clockwise from right front) Dolores Baraty, Joanna Harris, Nettie Elliott, Irma Reeb, Olive Kelly, Albina Watson, Katherine Miller, Doris Knowles, Mary Lou Sahm, Annie Waters, Jeanette Rothman, Betsy Blumenthal, Nancy Goldberg, Sally Myerovitz, Gladys Krohn, Ethel Chittam, and unidentified; (standing in back from left to right) Mildred McKenny, Vera Tucker, unidentified, Lillian Hahn, Lois Markel, Ruth ?, two unidentified members, and Joan Day. (Courtesy of Lois Markel.)

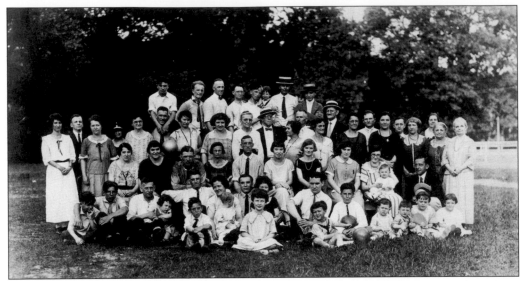

The annual picnic was continued in the early 1900s at Druid Hill Park. Later, it was held nearby at Carlin's Park. Fleet Bowman remembers fondly that Carlin's Park had a popular amusement park with a roller rink, a roller coaster, and many more attractions. Sadly, the park closed down. Helen Wells Leitner is seen here standing on the far right. Her nephew Rozelle McCall is holding Maureen, his daughter, in the far back row fifth from the left. (Courtesy of Christ Deaf Church.)

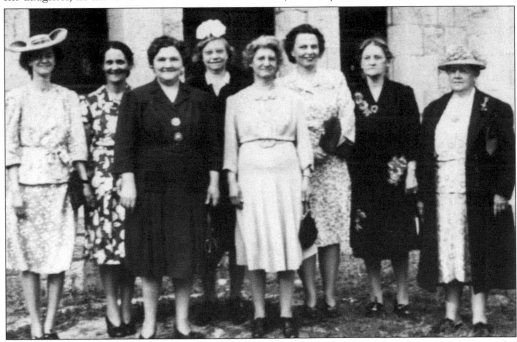

The Ladies' Aid Society was established in the early 1940s and hosted events, including the Strawberry Bazaar. Some of the funds they raised were spent on an installation of new kitchen equipment. From left to right are Edna Watkins; Clara McCall, treasurer; Mrs. Ray Kauffman, secretary; Mrs. James Foxwell; Margaret Sandebeck; Louise Price; Martha Fraley, vice president; and Mrs. Florence Brown. Missing from the photograph is Mrs. Louis McClain, president. (Courtesy of Christ Deaf Church.)

*Six*

# SPORTS

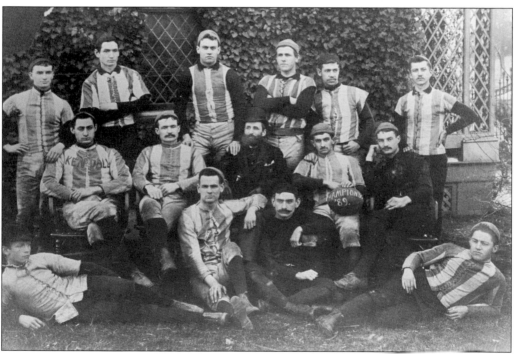

This tough-looking team from the Columbia Institution of the Deaf, now known as Gallaudet University, won the 1889 football championship. Frank Leitner is sitting with the "Champions '89" ball on his lap. Leitner was an athlete since his Kendall days. While attending Gallaudet, he was always on committees for activities in the Baltimore Deaf community or hanging out with his close friends, like George Veditz, James Wells, and his younger brother George Leitner. (Courtesy of Gallaudet University Archives.)

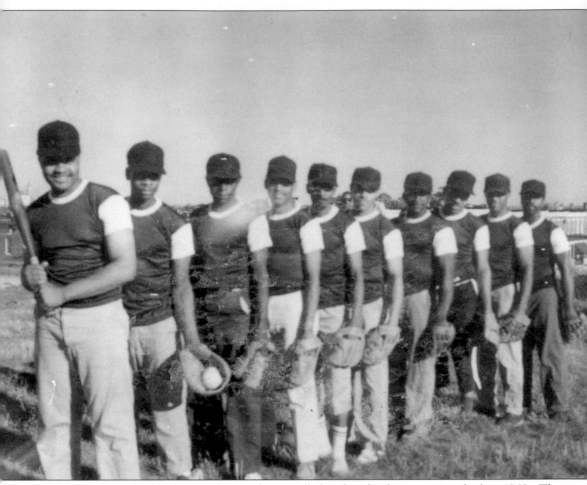

This Black Deaf softball team, the Hawks, proudly lined up for the camera in the late 1960s. The uniforms were paid for out of the players' hard-earned wages. Identified by Zellie Jones, from left to right are Donnell Wilson, Norman Jennings (with softball), Robert Hinton, Ellsworth Bouyer, William Johnson, Herbert Robinson, Ernest Hawkins, Donald Smith, Charles Christian, and Perry Chase. (Courtesy of Zelephiene Jennings Jones.)

Edwin Markel (left) practices with a frequent visitor to Baltimore, his deaf brother-in-law Rudolph Cooper (right) of North Carolina. Both played for the SOC in the late 1940s. Cooper passed away during the Thanksgiving week in 2013. (Courtesy of Lois Markel.)

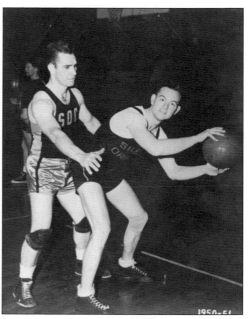

William O. "Dummy Decker" Dilworth was a lightweight prizefighter in the late 1800s and early 1900s. He continued to fight locally as a welterweight prizefighter after he got married to Catherine Martini in 1910. They had two children while he was still boxing before he retired in 1921. Dilworth is pictured in the center of this image in later years. Catherine is next to him, wearing a hat. (Courtesy of Christ Deaf Church.)

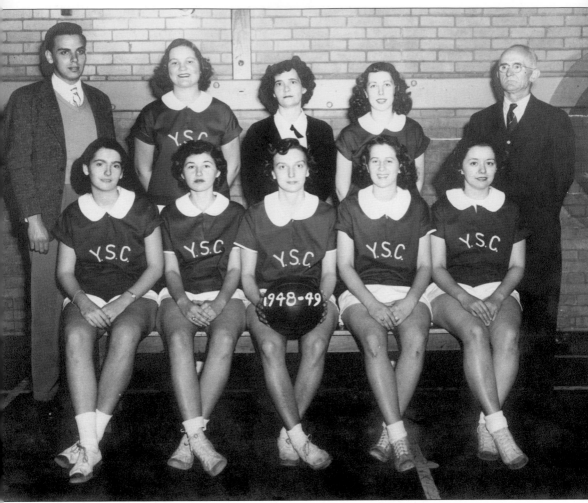

The YSC women's basketball team is seen here during the 1948–1949 season. Calvert Street Church was the only church that had basketball teams, which were established there by Rev. Louis Foxwell Sr. Nonmembers were welcome to join the both the men's and women's teams. This team included, from left to right, (seated) Maureen McCall, three unidentified players, and Joanna Harris; (standing) Fleet Bowman (coach), Lois Markel, Clara McCall (coach), and two unidentified players. (Courtesy of Lois Markel.)

At the first-annual basketball banquet for the Inter-Eastern States Basketball League of the Deaf, an attendee filled in the names of team members who had won awards. The most valuable player was H. Gabriel, and Grube won the sportsmanship award. The first team all-stars were Cory, P. Carnivale, Radvany, Gabriel, and Eberly, and the second team included W. Brizedine, Feinman, Connaso, Snyder, and Crush. (Courtesy of Christ Deaf Church.)

## Acknowledgement

Awards will be presented to the following:

★     ★     ★

Championship Trophy.........................Silent Athletic Club, Inc.
Runner-Up Trophy.........................South Jersey Silent Club, Inc.
Third Place Trophy.........................Youth Silent Club, Baltimore
Brotherhood Team Sportsmanship Trophy *Lancaster*
Individual Awards for players of the champion and runner-up teams.
Most Valuable Player Trophy *H. Gabriel*
Sportsmanship Trophy......... *Grube*

★     ★     ★

★ ★   ALL-STAR TEAM PLAYERS   ★ ★

| First Team | Second Team |
| --- | --- |
| *Cory* | *W. Brizedine* |
| *P. Carnivale* | *Feinman* |
| *Radvany* | *Connaso* |
| *Gabriel* | *Snyder* |
| *Eberly* | *Crush* |

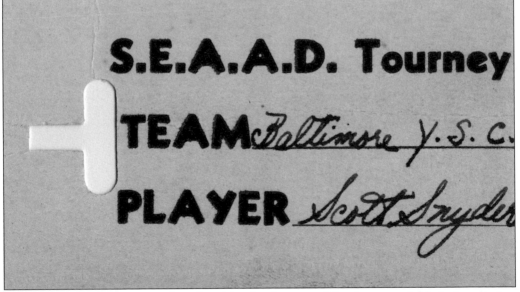

# S.E.A.A.D. Tourney
# TEAM *Baltimore Y.S.C.*
# PLAYER *Scott Snyder*

Scott Snyder's name was signed on this ticket for the annual Southeastern Athletic Association of the Deaf (SEAAD), when he played for the YSC team in 1948. The all-star player once scored a total of 215 points in 15 games, according to the April 27, 1944, edition of the *Sun Morning* newspaper. (Courtesy of Christ Deaf Church.)

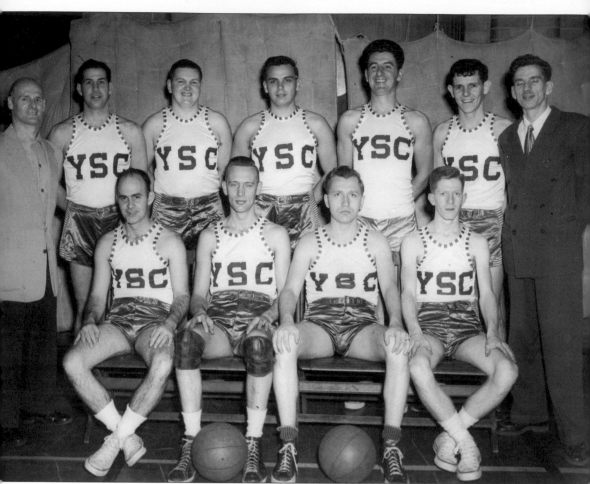

YSC men's teams have often played well and won in tournaments, attracting the attention of local fans, and created SOC as their rival team. This team included, from left to right, (seated) Bailis Hanke, A. Potts, Scott Snyder, and unidentified; (standing) unidentified, Robert Erdman, John Hook, Fleet Bowman, and three unidentified players. The photograph was taken during the 1947–1948 season. (Courtesy of Christ Deaf Church.)

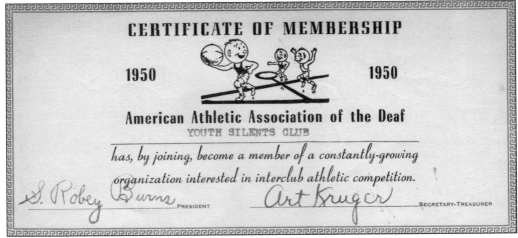

The American Athletic Association of the Deaf (AAAD) registered a Deaf club team membership card to each team every year. This 1950 YSC team membership card features the signature of the "father of AAAD," Art Kruger, and lists S. Robey Burns as the president. According to the Gallaudet athletics website, Kruger was a deaf sports enthusiast who helped found the AAAD after organizing the first national Deaf basketball tournament in 1945. (Courtesy of Christ Deaf Church.)

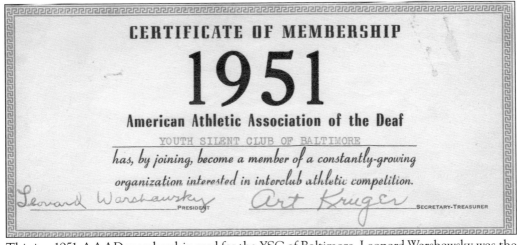

This is a 1951 AAAD membership card for the YSC of Baltimore. Leonard Warshawsky was the president and Art Kruger was the secretary-treasurer. (Courtesy of Christ Deaf Church.)

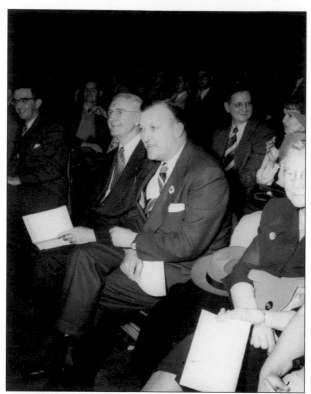

These fans in the VIP section of a 1951 game attended many exciting games. Seated second and third from the left are MSD superintendent Dr. Ignatius Bjorlee and Baltimore mayor T.R. McKeldin, who later became the governor of Maryland and was Judge Charles E. Moylan's former law partner. Rev. Louis Foxwell Sr. is on the far left. (Courtesy of Christ Deaf Church.)

In the late 1960s and early 1970s, the Black Deaf men's softball team played against other Deaf teams. Identified by Zellie Jones, from left to right are (first row) Perry Chase, Ernest Hawkins, Charles Weaver, James Cheese, and Gillis Diggs; (second row) Norman Jennings (being playful for the camera), Robert Hinton, Donald Chase, Charles Christian, and Ellsworth Bouyer. (Courtesy of Zelephiene Jennings Jones.)

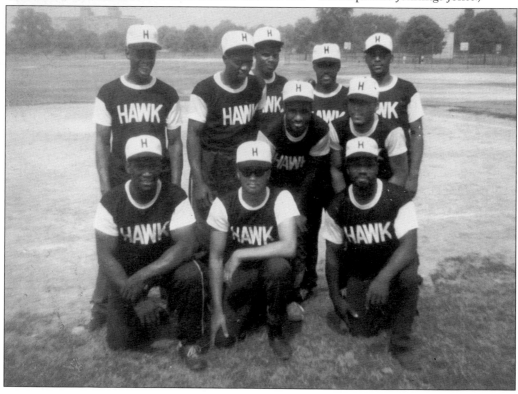

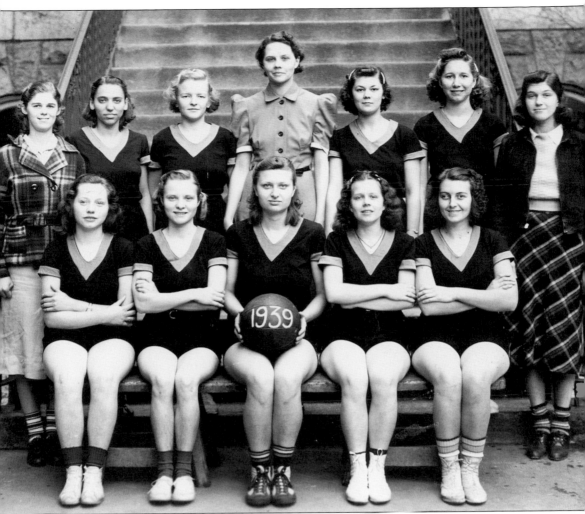

This photograph shows the 1939 MSD women's basketball team, which included, from left to right, (seated) R. Dilley, Ann Laurie Meredith, Cecelia Wolsky, L. Markland, and Ruby Howes; (standing) Sophia Doris Faupel (timer), Marjorie Willey, D. Dorsett, Miss Quinn (coach), P. Main, I. Quidas, and Nancy Tannebaum (scorer). Wolsky and Tannebaum were often seen around Baltimore's activities, and Wolsky later married James Barrack, a good friend of Rozelle McCall's. (Courtesy of Christ Deaf Church.)

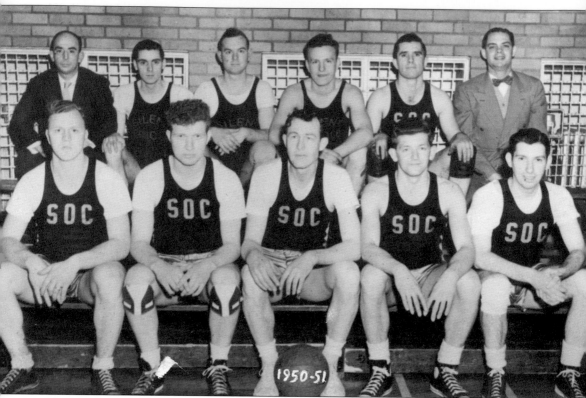

This photograph shows the SOC men's basketball team during the 1950–1951 season. Among the other team members, Herman Schwartz is on the far right in the first row, Eugene Rubinstein is next to him, and Billy Hughes of Oklahoma is next to him, in the center of the first row. Edwin Markel is second from right in the second row. (Courtesy of Lois Markel.)

Dorothy Leitch had just graduated from MSD and joined the YSC women's basketball team when this photograph was taken in 1951. She had a twin deaf brother, Donald, and a deaf sister, Vivian, and lived in Baltimore with her deaf parents, Herbert and Gladys Leitch. The twins enrolled at Gallaudet after spending two years as seniors at MSD so they could get scholarships to Gallaudet. Dorothy then met Richard "Dick" Caswell and married him soon after. She also became a Phi Kappa Zeta sorority member that same year. (Courtesy of Joyce Jacobson Leitch.)

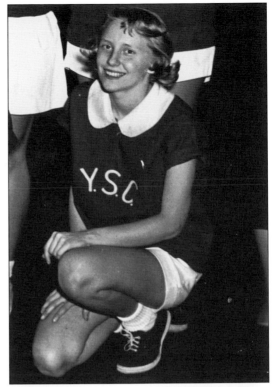

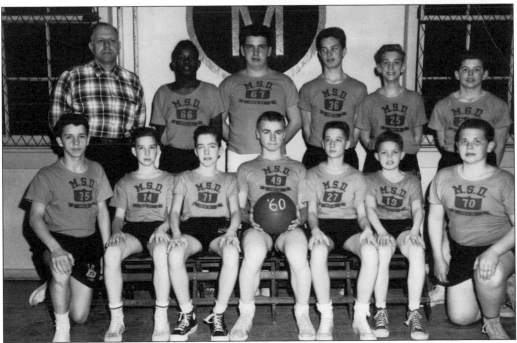

The MSD basketball team welcomed Milbert Jones after he enrolled at MSD in 1957 with a few other students from the Maryland School for Deaf Colored Youths at Overlea. Jones is second from left in the second row, next to the coach. (Courtesy of Milbert and Zelephiene Jennings Jones.)

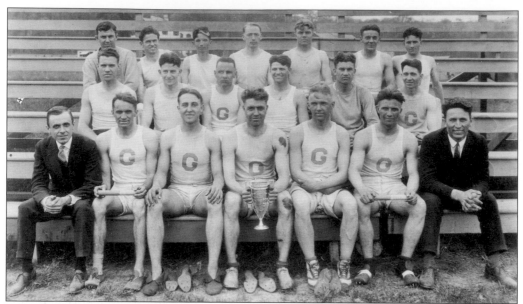

Rozelle McCall joined the track team at Gallaudet after graduating from MSD. In this team picture from 1923, McCall is third from left in the third row. McCall was also a basketball player there. (Courtesy of Gallaudet University Archives.)

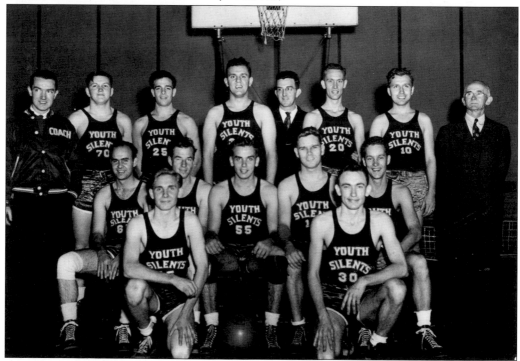

The YSC men's basketball team was run by Rev. Louis Foxwell Sr., the athletic director at Calvert Street Church. This 1947–1948 team included, from left to right, (first row) T. Baraty and O. Gilbert; (second row) Bailis Hanke, Alton Boyer, Fleet Bowman, James Barrack, and J. Ruley; (third row) Bill Harris (coach), John Hook, J. McKenny, T.T. Mohr, Reverend Foxwell, A. Potts, S. Snyder, and James Foxwell (the reverend's father and a coach). (Courtesy of Christ Deaf Church.)

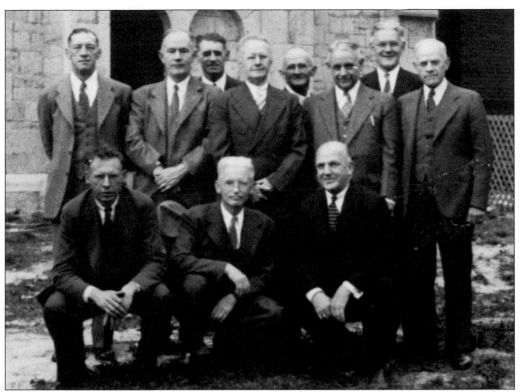

These former men's baseball players posed for the camera in May 1943. They are, from left to right, (kneeling) Howard Hood, Rozelle McCall, and Ray M. Kauffman; (standing) S. Sandebeck, Charles E. Moylan (the child of a deaf adult), Howell Elliott, Harry G. Benson, James B. Foxwell, George Leitner, Jacob King, and Harry Creager. Leitner continued to manage and coach the Baltimore Deaf championship teams for years after his professional baseball career was over. (Courtesy of Christ Deaf Church.)

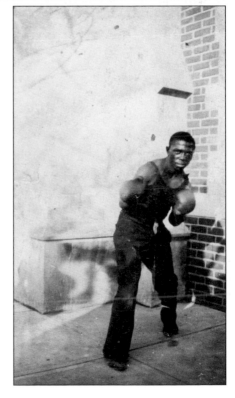

Jerome Horsey, one of the Whatcoat Deaf Mission leaders, was a lightweight prizefighter in the early 1930s. He was already married and had a child by age 19, when he began fighting professionally. (Courtesy of Christ Deaf Church.)

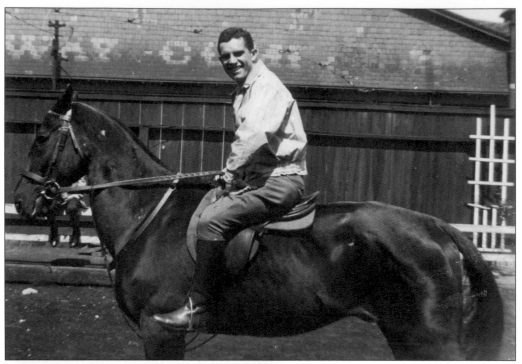

Edwin Markel is seen here in the 1940s after graduating from MSD in 1941. He enjoyed horse riding at Hechter's Riding School at Druid Hill Park. (Courtesy of Lois Markel.)

Maureen McCall was one of very few hearing children of deaf adults (or CODAs) to play on a Deaf sports team. Because sign language was her first language, she could understand her deaf coaches and teammates and participate fully. She was an extraordinary athlete, like her deaf father, Rozelle McCall. (Courtesy of Elinor Reese.)

From left to right, Alton Boyer, Scott Snyder, and John Hook proudly show off the basketball trophy their YSC team won at one of annual SEAAD tournaments. The year is unknown. (Courtesy of Christ Deaf Church.)

Many students from the Baltimore area were athletes, but there was no football team at MSD until David Denton became superintendent in 1968. Football then began in the fall of 1969. This photograph was taken between 1937 and 1940. Roger Myers and Edwin Markel are second and third from left in the first row, Herman Schwartz is fifth from left in the first row, Scott Snyder is second from left in the second row, and Fleet Bowman is second from right in the back row. (Courtesy of Christ Deaf Church.)

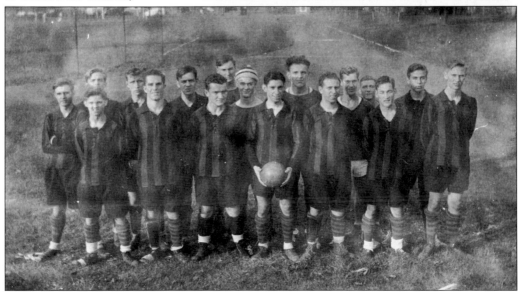

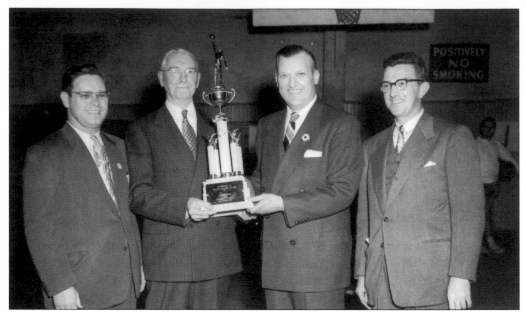

From left to right, James Barrack, MSD superintendent Dr. Ignatius Bjorlee, Baltimore mayor T.R. McKeldin, and athletic director Rev. Louis Foxwell all proudly receive the championship for the YSC men's team after a 1951 city basketball tournament. (Courtesy of Christ Deaf Church.)

SEAAD trophies were present for each team in 1948. YSC won second place, losing to the Spartanburg, South Carolina, Deaf Club basketball team 58-44. YSC was leading in the first and second quarters, but the South Carolinians took over after halftime, winning the championship. (Courtesy of Christ Deaf Church.)

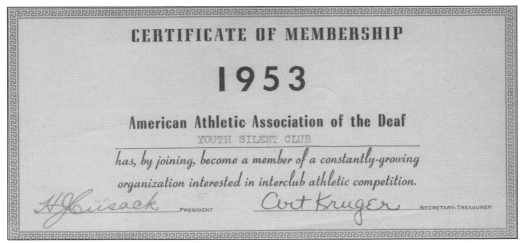

CERTIFICATE OF MEMBERSHIP

# 1953

## American Athletic Association of the Deaf

YOUTH SILENT CLUB

*has, by joining, become a member of a constantly-growing*
*organization interested in interclub athletic competition.*

H. Cusack PRESIDENT          Art Kruger SECRETARY-TREASURER

This is the American Athletic Association of the Deaf's 1953 membership card for the YSC team. H. Cusack was the president, and the "father of AAAD," Art Kruger, remained as the secretary-treasurer. (Courtesy of Christ Deaf Church.)

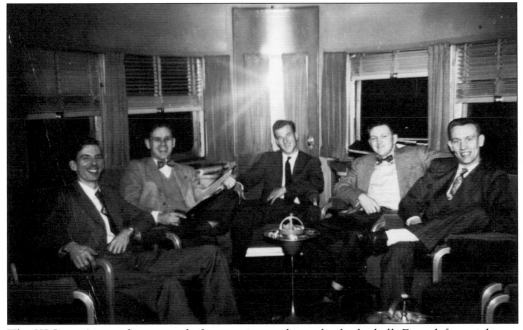

The YSC men's team hangs out before getting ready to play basketball. From left to right are unidentified, James Barrack, Alton Bouyer, John Hook, and A. Potts. (Courtesy of Christ Deaf Church.)

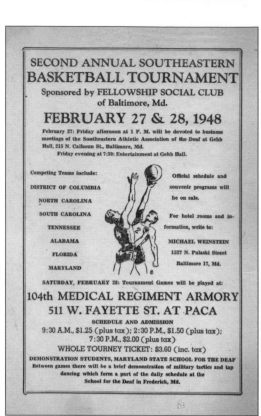

This is the original flyer for the second-annual SEAAD basketball tournament, which was held in Baltimore on February 27–28, 1948, with a small number of teams from the East Coast. The YSC men won second place in the tournament. Tickets only cost $3.60 for two full days of attendance. Note that MSD students came and gave military tactics and tap dancing demonstrations during the intermissions. The military tactics ceased when superintendent Bjorlee retired after 35 years at MSD. (Courtesy of Christ Deaf Church.)

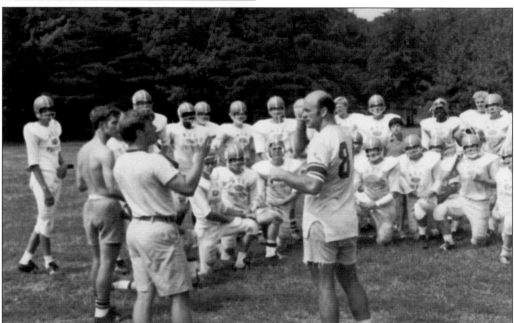

Donald Phelps was the head coach for the MSD football team during the 1972–1973 season, seen here. Benjamin and James Markel of Sykesville recalled that they were happy to play after a football team was established in 1969. This team had a record of six wins, eight losses, and two ties. (Courtesy of Christ Deaf Church.)

# Seven

# EVENTS AND GATHERINGS

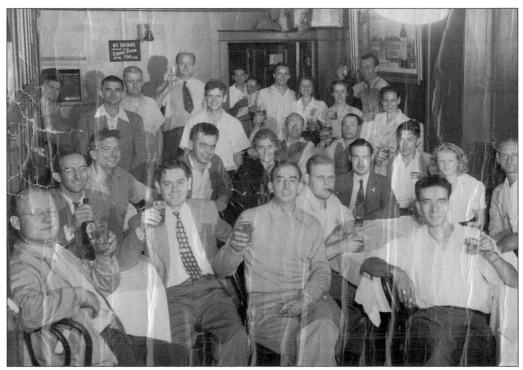

This 1946 photograph, which was stored rolled up, shows a good time at the Silent Oriole Club hall after work hours. In the back row, Thaddeus Juchno is second from left and Daniel Kalinowski is eighth from left. The location was at East Preston Street and North Charles Street. (Courtesy of Eugene and Manny Rubinstein.)

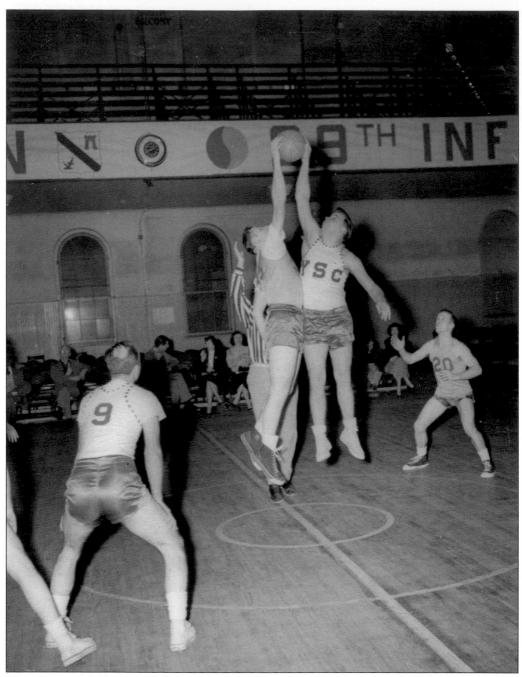

This photograph shows a YSC men's basketball game in Baltimore. Bailis Hanke is on left, and Fleet Bowman is on the right during a jump ball. (Courtesy of Christ Deaf Church.)

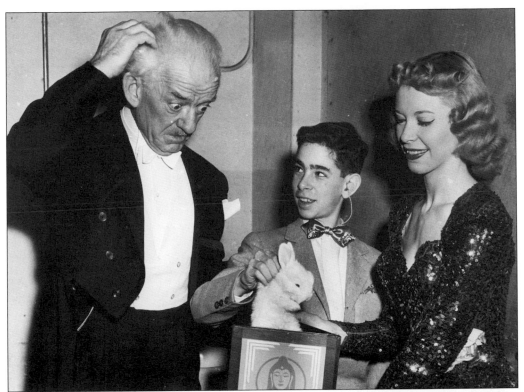

At age 13 in January 1952, Simon Carmel won first place at the citywide magic tournament at the famous Hippodrome Theatre in Baltimore. In this photograph, he is seen with world-famous magician Harry Blackstone Sr. and his assistant after receiving the $25 savings bond prize from Blackstone, who was a judge. By this time, Carmel had already appeared on the television show as a contestant a couple of times. (Courtesy of Simon J. Carmel.)

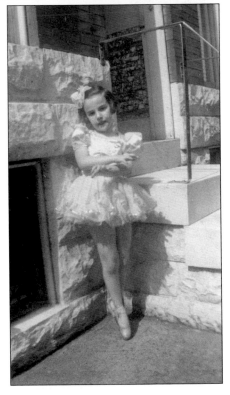

Deborah Meranski poses in her ballet costume in front of her home before going to her first recital. Her parents, Dr. Israel and Jeanette Meranski, encouraged her to learn all aspects of the arts, including fine arts and even piano lessons, despite the fact that she could not hear the music. Her ballet class was on North Charles Street. (Courtesy of Deborah Meranski Blumenson.)

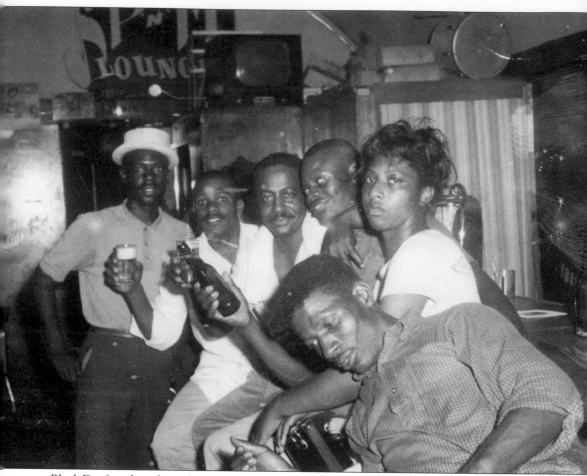

Black Deaf workers from the Cat's Paws Rubber Sole Plant went after work to relax over drinks at a lounge. Fourth from the left is Norman Jennings Sr. (Courtesy of Zelephiene Jennings Jones.)

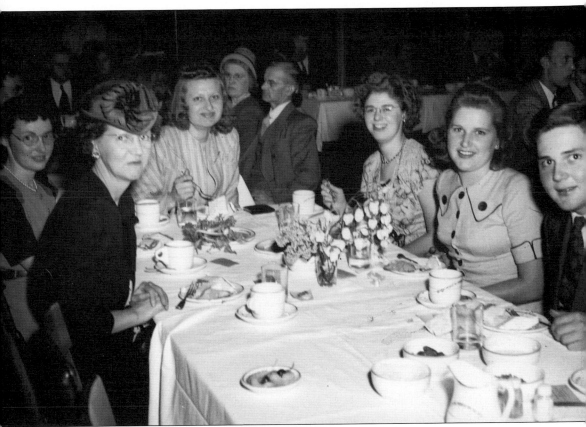

Cecelia Wolsky Barrack (third from the left) and Doris Faupel Knowles (fourth from the left) enjoy a special feast with a group to celebrate the 50th anniversary of Christ Deaf Church on April 7, 1946. (Courtesy of Christ Deaf Church.)

Clara McCall dressed up to attend church on a Sunday at Christ Deaf Church. She once traveled to Haiti to accomplish a mission. (Courtesy of Christ Deaf Church.)

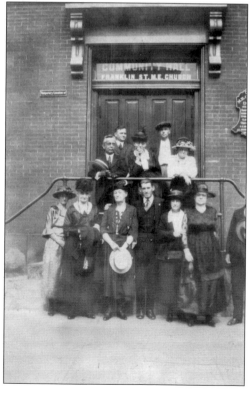

In 1800s, everybody attended the community hall at the Franklin Street Methodist Episcopal Church to play games and be social. Later, another hall was established in honor of Philip Gehb, a deaf farmer from Mt. Winan who donated generously to Reverend Moylan's church. (Courtesy of Christ Deaf Church.)

Robert and Nellie Davis relax with a drink. Nellie, the godmother of Zelephiene Jennings, dropped off and picked up "Zellie" from the William S. Baer School, a few blocks away. Zellie, coming from a large deaf family, was not happy that the school did not allow the use of sign language. She was delighted when she was transferred to MSD in 1962, where she could communicate freely. (Courtesy of Zelephiene Jennings Jones.)

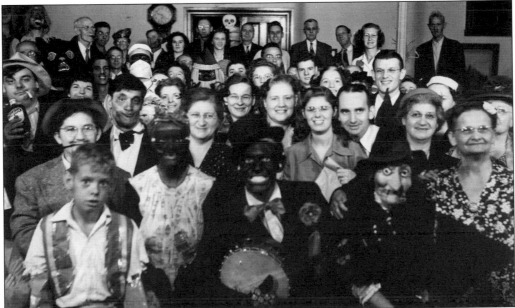

The Gehb Social Fellowship Hall hosted this Halloween event in 1948. Everybody smiled for the camera with a mix of costumes and regular dress for the event. Note the clock on the wall, showing that the party was still going on at 9:20 p.m. Catherine Dilworth, the wife of former lightweight and welterweight deaf prizefighter William Dilworth, is on the far right smiling at the camera. (Courtesy of Christ Deaf Church.)

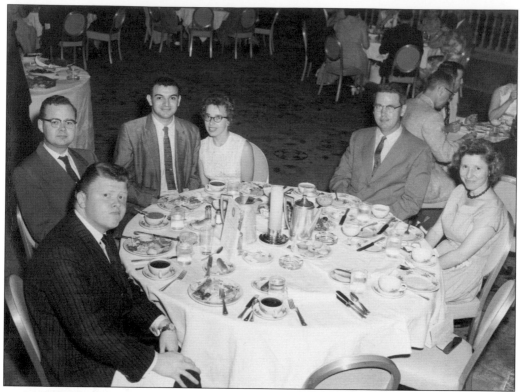

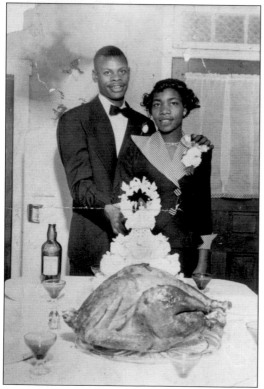

This photograph was taken at one of the NFSD Baltimore Chapter's annual banquets. In the middle of this round table, third and fourth from left, are Louis and Harriet Greenberg. Louis graduated from the Virginia School for the Deaf and Blind. He rode on frequent trips to Baltimore in the car with his mother to visit Harriet and teach her sign language. Later, he moved to Baltimore to marry Harriet, who was happy to use sign language to communicate. (Courtesy of Harriet and Louis Greenberg.)

Norman Jennings, an Overlea School alumni, met Anna Mae Peoples of Pittsboro, North Carolina, when she was visiting her oldest sister in Baltimore. She then moved to Baltimore and they got married. Rev. Louis Foxwell Sr. led the wedding ceremony. Norman worked at the Cat's Paws Rubber Sole Plant on Ostend Street and lived in the Westport area. They gave birth to all deaf children, who all attended and graduated MSD in Frederick. (Courtesy of Zelephiene Jennings Jones.)

Between 1953 and 1964, Milbert Jones, who was originally from the Eastern Shore, often traveled to Baltimore by ferry before the Bay Bridge opened in April 1964. This is one of the places in Baltimore where he would stop and enjoy a relaxing time with a soda and a snack. (Courtesy of Milbert and Zelephiene Jones.)

Maureen McCall, a child of deaf adults, and John Hook, who was deaf, were married in Baltimore on June 20, 1951. The two grew up together all their lives through their association with Christ Deaf Church and social clubs. Maureen's deaf parents, Rozelle and Clara McCall, stand proudly on the left. The marriage was short-lived, however, and both Maureen and John went on to separate lives. (Courtesy of Elinor Reese.)

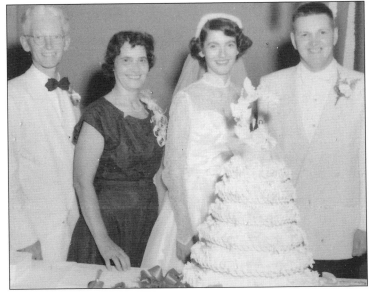

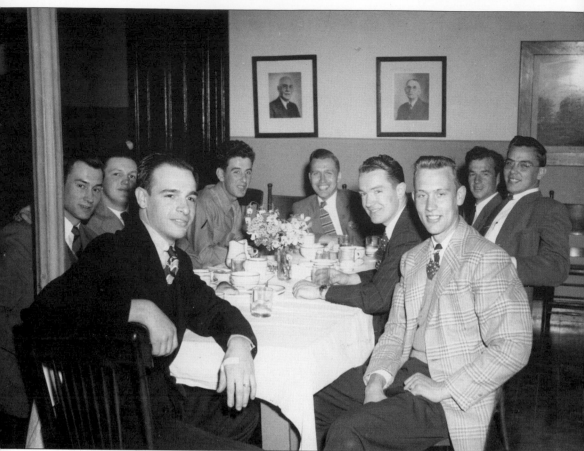

These young men enjoyed socializing and often played sports together for fun. John Hook is sitting third from the left front, Scott Snyder is fifth from the left front, and J. McKenny is in the left front. Fleet Bowman is third from the right front and Alton Boyer is second from the right front. Rev. Daniel E. Moylan's framed photograph is hanging on the wall on the left, next to Philip Gehb's framed photograph. (Courtesy of Christ Deaf Church.)

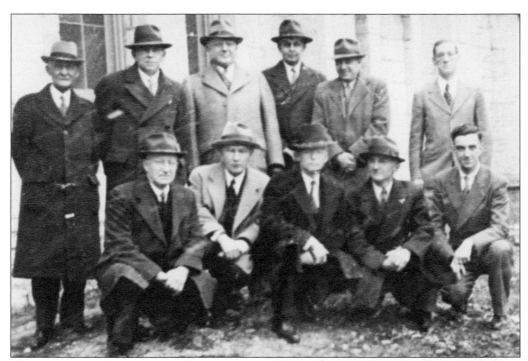

Christ Deaf Church had a service and took this picture afterwards, while it snowed outside on a chilly day. This group includes, from left to right, (first row) William Nicol, Judge Charles Moylan, Rozelle McCall, James B. Foxwell, and Rev. Louis Foxwell Sr.; (second row) Charles Paulus, George Brown, Ray M. Kauffman, Oliver Watkins, August Herdtfelder, and Stephen Sandebeck. (Courtesy of Christ Deaf Church.)

Norman Jennings Sr. was all dressed up in his best clothes to go bowling with his friends and have a relaxing time. (Courtesy of Zelephiene Jennings Jones.)

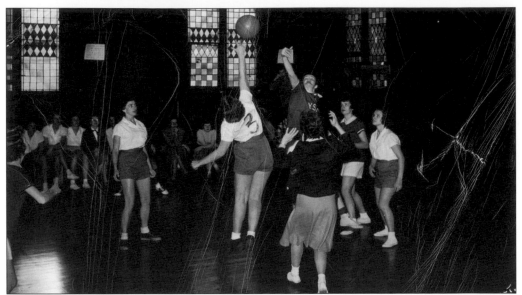

The YSC women's basketball team plays against another team in the "Ole Jim" gymnasium on the Gallaudet campus. The beautiful stained glass windows are a beautiful feature of the Ole Jim building, which still stands today. (Courtesy of Christ Deaf Church.)

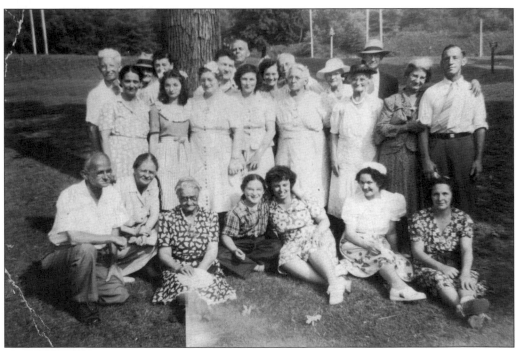

Christ Deaf Church holds its annual picnic at Herring Park in 1944. Rozelle McCall is standing on the far left and is very tan from one of the frequent fishing trips he took with friends. His wife, Clara, is standing in front of him. Ruth Atkins is seated, second from left. (Courtesy of Christ Deaf Church.)

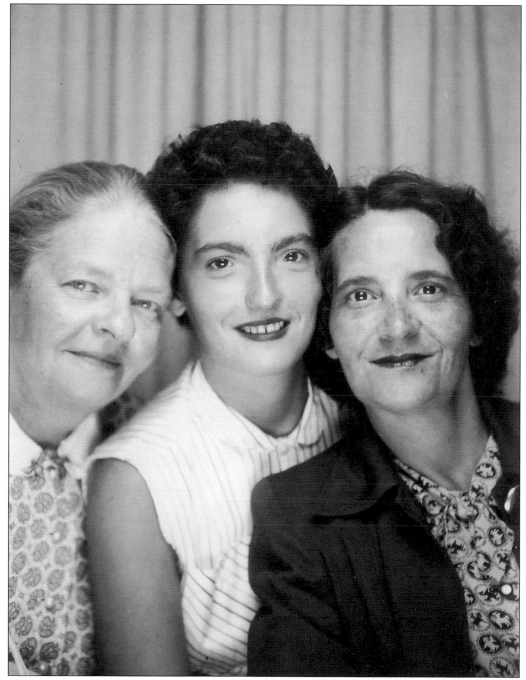

From left to right, Ruth Atkins, Maureen McCall, and Clara McCall enjoy a self-portrait in a photo booth on an outing. (Courtesy of Elinor Reese.)

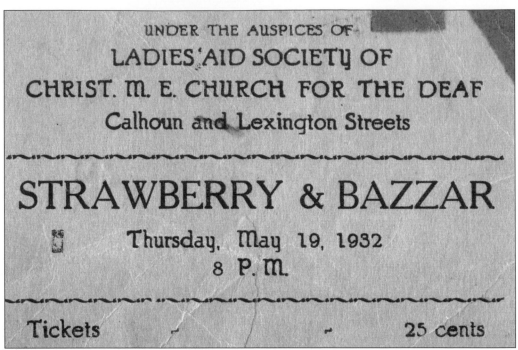

UNDER THE AUSPICES OF

LADIES' AID SOCIETY OF

CHRIST. M. E. CHURCH FOR THE DEAF

Calhoun and Lexington Streets

# STRAWBERRY & BAZZAR

Thursday, May 19, 1932
8 P. M.

Tickets                25 cents

The Ladies' Aid Society hosted the Strawberry Bazaar on May 19, 1932, selling tickets for only 25¢ per person. (Courtesy of Christ Deaf Church.)

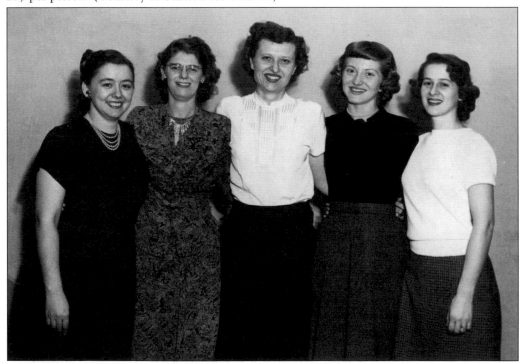

Old MSD schoolmates enjoy their night together at a reunion. They are, from left to right, Joanna Sturgis Harris, Doris Faupel Knowles, Cecelia Wolsky Barrack, unidentified, and Mary Lou Jones Sahm. (Courtesy of Christ Deaf Church.)

This wedding photograph was taken in Baltimore of Joanna Sturgis and William "Bill" Harris, her late husband and MSD schoolmate. Both were active with Christ Deaf Church. Joanna was also involved with the Silent Clover Society and played basketball for the YSC in the 1950s. (Courtesy of Lois Markel.)

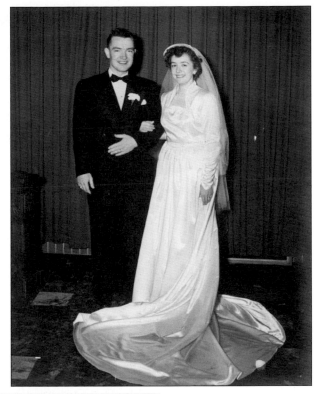

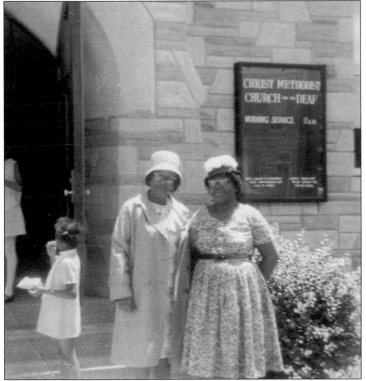

Bessie Hall (left) and Sadie Chase were proud to stand in front of the Methodist Church for the Deaf, on Loch Raven Street, before the 11:00 a.m. service. Zelephiene Jennings was only 13 years old when she bought a new camera with her entire savings. With delight, she took a lot of pictures in the 1960s and 1970s. (Courtesy of Zelephiene Jennings Jones.)

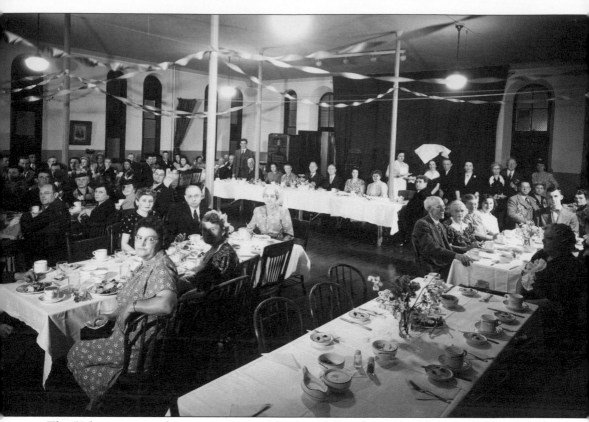

The 50th-anniversary banquet was one of the special feasts hosted by Christ Deaf Church. Judge Charles E. Moylan Sr. and his wife attended the banquet. They are seated in the middle of the long table in the background. (Courtesy of Christ Deaf Church.)

In the late 1950s, Alfred "Sonny" Sonnenstrahl went door to door to install homemade doorbell light systems for members of the Baltimore Deaf community. (Courtesy of Joyce Jacobson Leitch.)

This is likely one of the last photographs of George M. Leitner, posing with his great-grandchildren Lee and Mark in the fall or winter of 1959. Claire, the children's mother, was the daughter of Clarence Wells Leitner and Helen Beacham. After Clarence's death in 1938, Max Schwartz, Helen's second husband, adopted Claire and her brother Barry. (Courtesy of Lee Berenson.)

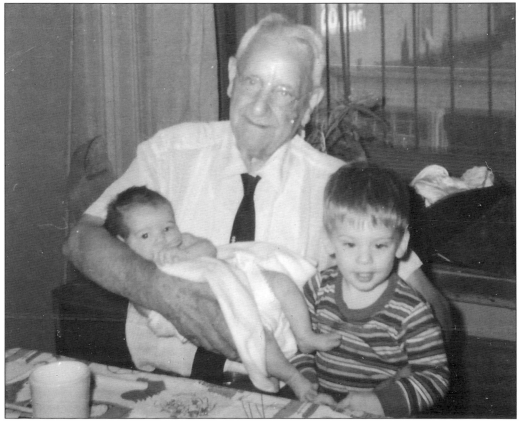

From left to right, Daniel Kalinowski, Edwin Markel, and Thaddeus Juchno celebrated Markel's graduation from MSD in 1941 at the SOC, which used to have a bar on East Preston Street and North Charles Street, with a counter and tables to sit at during happy hour. Note that Markel is holding up a different drink from the others. He never drank any alcohol, instead opting for soda. (Courtesy of Lois Markel.)

The Cat's Paws Rubber Soles Plant had a high number of black deaf employees, including Norman Jennings Sr. The plant, now abandoned, was located at Warner and Ostend Streets before moving to Waltham, Massachusetts. Jennings's daughter Zelephiene Jennings Jones remembers fondly that her father did not need to shower at home because he showered at the plant each day after work. (Courtesy of Robert Geary.)

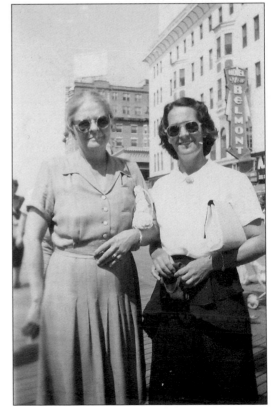

Ruth Atkins (left) and Clara McCall, close lifelong friends, took this trip together in the 1940s away from Baltimore. Note the very old sign for the Belmont Hotel behind them. (Courtesy of Elinor Reese.)

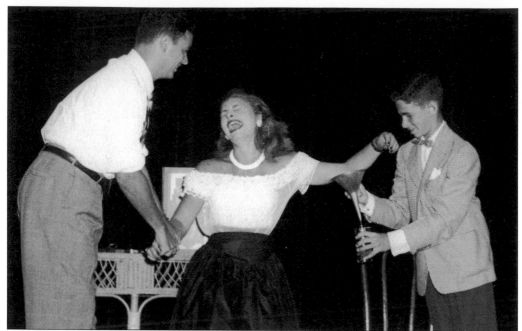

Simon Carmel (right), a young deaf magician, often gave shows for the Boy Scouts and at church and synagogue events. Here, two unidentified volunteers came to the stage to let Simon use his comedy magic trick on them to entertain the audience. Today, Carmel travels all over the world as a magician and has written a few books. (Courtesy of Simon J. Carmel.)

Helen and Fannie Wells show their sisterly love in the 1800s while playing outside on a special day. (Courtesy of Lee Berenson.)

During his single days, Edwin Markel often went horse riding at Druid Hill Park (right) after work at Lockheed Martin's manufacturing plant. He yearned to find the right woman, and in 1943 his friend Grover Poole suggested that he meet Lois Cooper, who came from a family living on a farm in North Carolina. After four years of courtship, they got married in 1947, settling on a farm in Pennsylvania. Later, they moved to Sykesville, Maryland, and raised five deaf sons. Their love had lasted for 65 years when Edwin passed away in 2013. (Both courtesy of Lois Markel.)

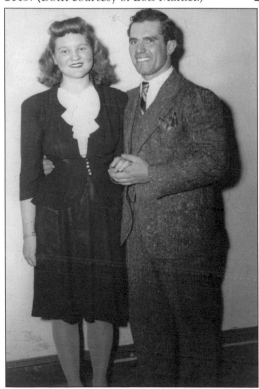

Helen Leitner is believed to be in the center of this early-1900s photograph. She was the daughter of George and Helen Leitner. Wearing her dark jacket, she poses with family friends during an outing at a farm. (Courtesy of Lee Berenson.)

Deaf talkers socialize and enjoy their meal at a gathering. From left to right are Ruth Ann Nalley Frohn; a young deaf girl named Dolores Abbott, in the high chair; an unidentified man signing "daddy" to her; Dolores's deaf mother, Carol Abbott; and Carol's mother, Magdalene Cooper Ziennk, who was the sister of Lois Markel. (Courtesy of Christ Deaf Church.)

Proud parents Donnell Wilson and his first wife, Mary, pose with their children at an Easter church service in 1970. (Courtesy of Christ Deaf Church.)

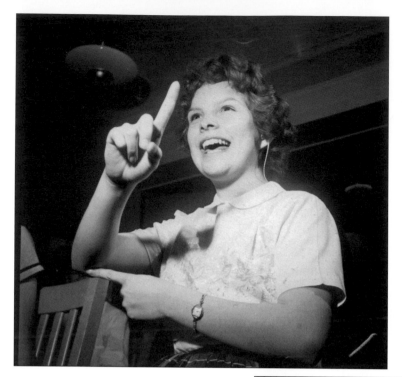

A deaf woman signs during the social hour at the social fellowship hall in the early 1960s. (Courtesy of Christ Deaf Church.)

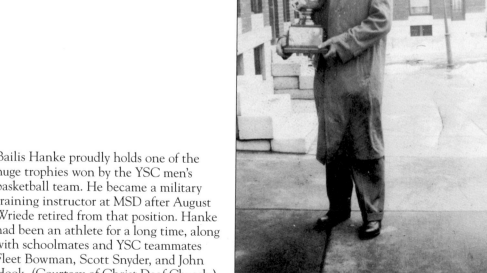

Bailis Hanke proudly holds one of the huge trophies won by the YSC men's basketball team. He became a military training instructor at MSD after August Wriede retired from that position. Hanke had been an athlete for a long time, along with schoolmates and YSC teammates Fleet Bowman, Scott Snyder, and John Hook. (Courtesy of Christ Deaf Church.)

## *Eight*

# CHILDREN AND SIBLINGS OF DEAF ADULTS

George and Helen Leitner's son Clarence Wells Leitner, who went by his middle name, was an intelligent boy, completing his high school education at age 13. He grew up surrounded by deaf peers. He enrolled at Baltimore Polytechnic Institute and then went to law school. At 17 years old, he decided to enroll in the Army. Aviation training was his choice, as he was thinking about becoming a flight trainer. Instead, he became the assistant editor of the *Evening Sun* newspaper. (Courtesy of Lee Berenson.)

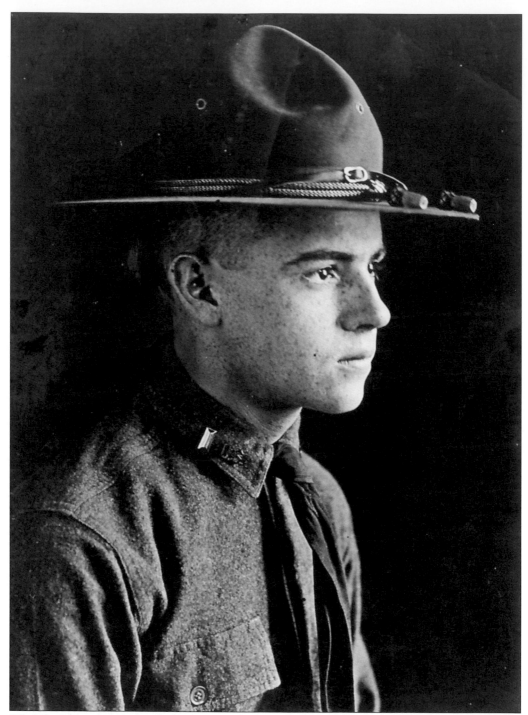

While he was serving as an intelligence officer, C. Wells Leitner wrote several letters home missing his family, including his sister Helen. He took the position because of his newspaper and law training experience. He stayed in Baltimore and remained with two newspaper companies, the *Evening Sun*, and *North East Home News*, until joining the military to serve as a pilot in World War I. (Courtesy of Lee Berenson.)

August Herdtfelder, a deaf writer for *American Deaf Citizen* and a close Leitner family friend, wrote about C. Wells Leitner in 1938 after his unfortunate death at age 41. He praised Leitner as a brilliant assistant editor and writer. The ports and shipyards had fascinated Leitner as a young man, and he even wrote a small book about them called *Export, Import and Port Facilities*. (Courtesy of Lee Berenson.)

A group of *Baltimore Sun* employees hangs out with Leitner (bottom right) in front of a cozy fireplace in 1931. Leigh C. Sanders, a sometime *Sun* photographer, took the photograph, as his name is written on it. Later on, in 1956, the Sanders family established Sanders' Corner, a small restaurant and homemade ice cream stand on Cromwell Bridge Road that operated for years. (Courtesy of Lee Berenson.)

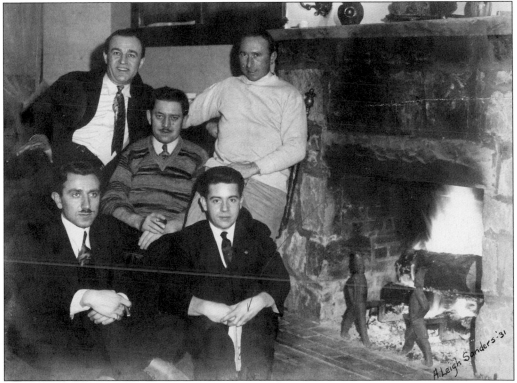

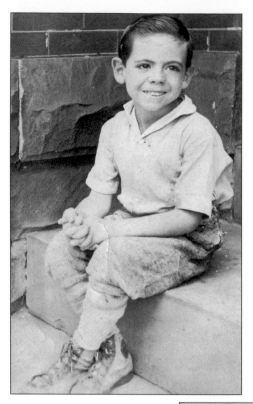

Wells Norris Leitner, C. Wells Leitner's son and George Leitner's grandson, was born in 1921 and grew up surrounded by both children of deaf adults and deaf family members. After C. Wells Leitner divorced his first wife, Elizabeth Norris, he raised the younger Wells until marrying Helen Beacham. (Courtesy of Lee Berenson.)

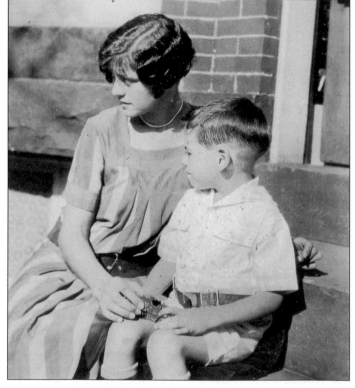

Helen Beacham, shown here with Norris in 1927, entered young Wells's life at an early age and had two more children with Clarence, Claire and Barry. C. Wells Leitner was very involved with the *Evening Sun* at that time as an assistant editor. The Deaf community highly admired him, including George W. Veditz, who wrote articles about him and his deaf family. (Courtesy of Lee Berenson.)

C. Wells Leitner stands next to his oldest son, Wells Norris Leitner. The two were known as "Big Wells" and "Little Wells." Wells Norris Leitner left Baltimore in his late teens before joining the military and settling in the Midwest, where he settled and raised a family. His children never knew he had a family in Maryland until Wells Norris Leitner's niece Lee Berenson got in touch. Wells Norris then had a heartfelt reunion with his niece, introducing her to his children shortly before his death in 2002. (Courtesy of Lee Berenson.)

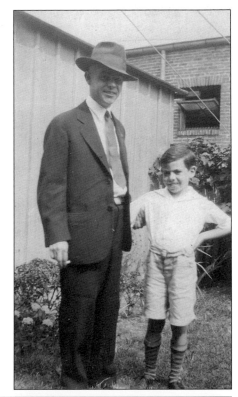

C. Wells Leitner is seen here on the far right with other children of deaf adults and his younger deaf sister Helen, second from left. This photograph was taken in the early 1900s. (Courtesy of Lee Berenson.)

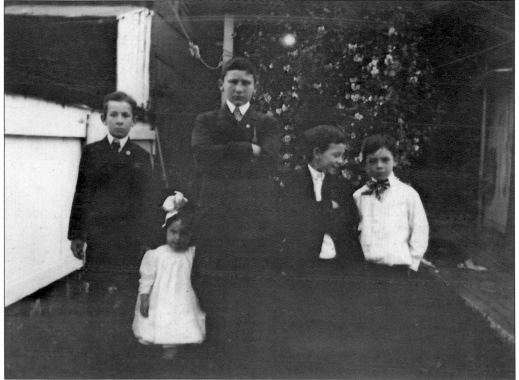

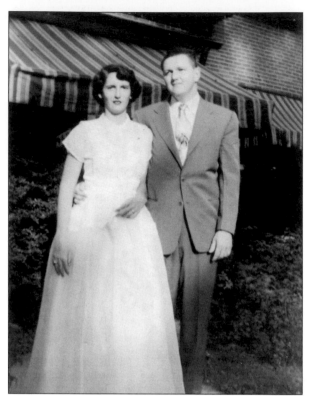

Maureen McCall, a child of deaf adults, and John Hook, who was deaf, were both members of Christ Deaf Church and longtime childhood friends. They are seen here on their wedding day. Unfortunately, their marriage was short-lived. (Courtesy of Elinor Reese.)

Maureen McCall was born in 1933. She is seen here with her proud young deaf mother, Clara McCall. (Courtesy of Elinor Reese.)

During and after her days at Eastern High School, Maureen grew up as an active teenager who participated in sports and social activities with the young Deaf group, including trips to Ocean City in the summers. (Courtesy of Elinor Reese.)

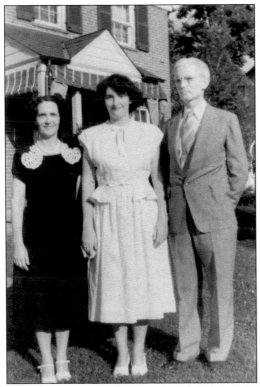

Maureen proudly stands with her parents, Clara and Rozelle McCall, in the 1950s. (Courtesy of Elinor Reese.)

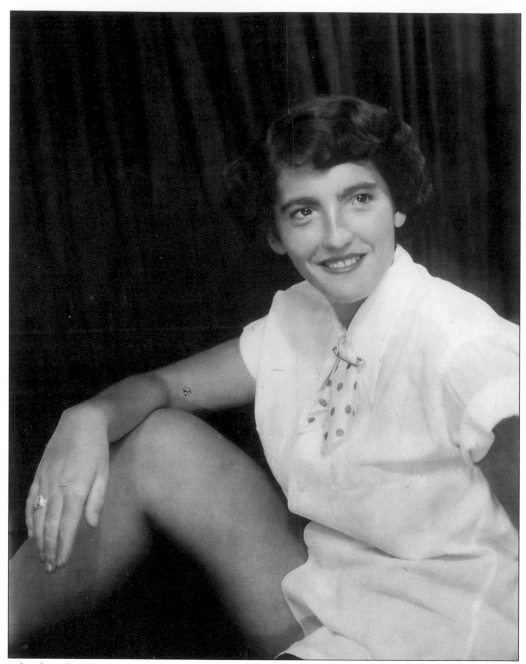

After her short marriage to John Hook, Maureen McCall went on to work for Eastern Airlines in Florida and then Lockheed Martin until her retirement. She remained close to her mother, Clara, and her godmother, Ruth Adkins, who both also moved to Florida and lived near her. In the 1980s, her father, Rozelle McCall, and his second wife, Carmen, moved to Florida as well. Maureen succumbed to lung cancer in August 2012. (Courtesy of Elinor Reese.)

Fannie A. Wells was the only hearing child of James and Fannie Wells. She often associated with the deaf children and adults and used sign language as her first language. With her signing skills, she later worked at the Virginia School for Deaf Colored Youths in Hampton, Virginia, while her deaf son, Rozelle McCall, was at MSD. (Courtesy of Lee Berenson.)

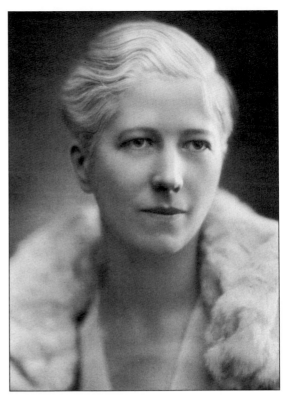

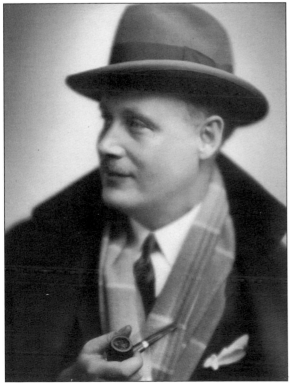

Sidney R. McCall was a private contractor who did construction for the City of Baltimore. He married Fannie and they had two children, a deaf son, Rozelle, and a hearing daughter, Mary. The marriage was brief, however, and Fannie then went to work at the Virginia School for Deaf Colored Youths. (Courtesy of Lee Berenson.)

119

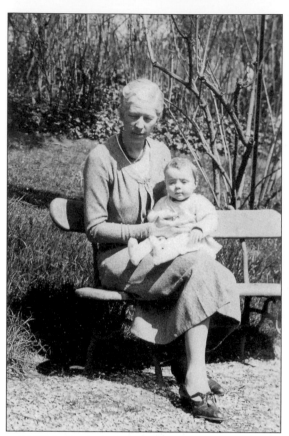

Fannie A. Wells is seen here in her later years with her grandson Dick Lloyd. Her daughter Mary settled in New York with her family, and Fannie lived with them until she met and married her second husband, Edgar Earl. (Courtesy of Lee Berenson.)

George W. Veditz's two sisters are seen here, first and second from the left. On the right is George's wife, Elizabeth "Bessie," whom George met at the Colorado School for the Deaf. Bessie stayed in Colorado until her retirement after George's death. Coincidentally, Veditz's nephew Harry Veditz became the editor of the *Baltimore Sun* while George Leitner and his son C. Wells worked there. (Courtesy of Colorado School for the Deaf and Blind.)

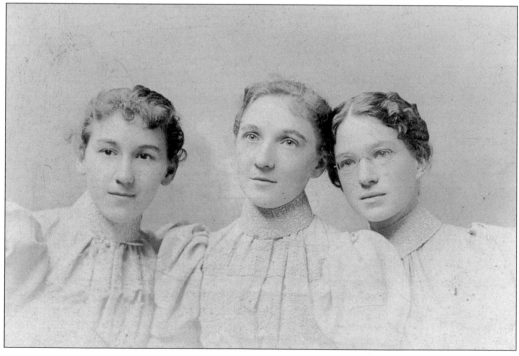

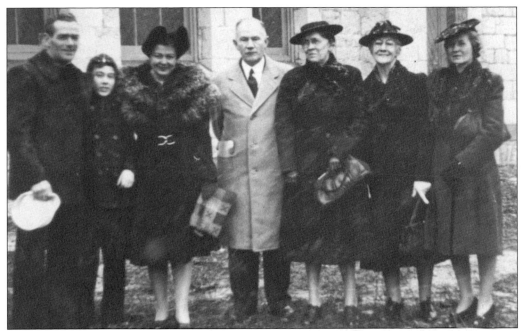

Charles E. Moylan Sr. stands with his family on a special visit to the church. From left to right are Bill Puls, the son-in-law of Mamie Geraghty, Reverend Moylan's sister; Charles Moylan Jr.; Anna Moylan, Charles Sr.'s wife; Charles Moylan Sr.; unidentified; and Margaret Puls, the daughter of Mamie Geraghty and Rev. Daniel Moylan's niece. Charles Sr. was the president of the MSD school board, and his son went on to be on the board as well. (Courtesy of Christ Deaf Church.)

Brothers Eugene and Manny Rubenstein, seen here with their sisters, had two different kinds of communication in their divided household, both signing and speaking. The siblings of deaf adults remained close growing up together. All their sisters passed away, leaving Eugene and Manny to stay close to each other, as brotherly neighbors checking on each other. (Courtesy of Eugene and Manny Rubinstein.)

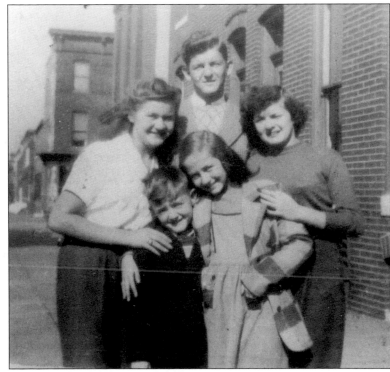

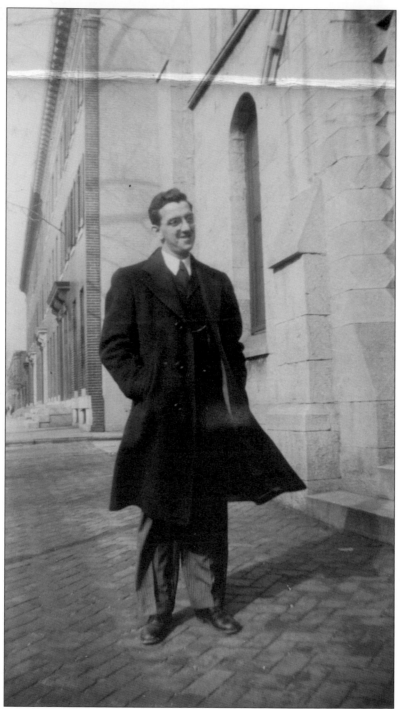

Rev. Louis Foxwell Sr. was the son of deaf parents, James and Annie Foxwell. He became the pastor of Christ Deaf Church after Rev. Daniel Moylan's death in 1943. At his deathbed, Moylan pleaded with Foxwell to follow in his footsteps and take over the Deaf service. Foxwell started combining the white and black Deaf services into one congregation, with the Whatcoat Deaf Mission worshippers joining his congregation. (Courtesy of Christ Deaf Church.)

Rev. Louis Foxwell, pictured on the right with his wife, Ruth, became the associate pastor and then the pastor of Christ Deaf Church after Rev. Daniel Moylan's death in 1943. (Courtesy of Christ Deaf Church.)

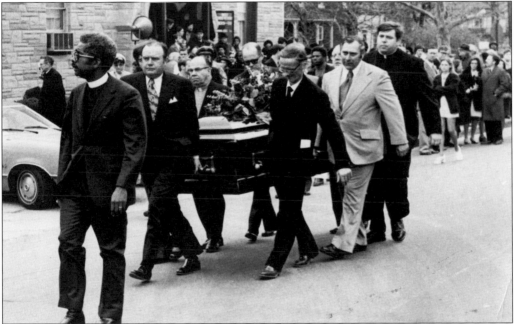

April 2, 1974, was one of the saddest days for the Deaf community in Baltimore and statewide. Rev. Louis Foxwell Sr. was shot and killed by two teenagers, aged 17 and 19, in a failed robbery attempt in the driveway next to Foxwell's house. The community mourned, with more than 1,000 people attending the funeral and 158 vehicles led by police escorts through the opened tollbooths across the bridge to the Eastern Shore all the way from Baltimore to bury him at his favorite spot in Easton, Maryland. Zelephiene Jennings Jones remembered renting a car and loading many people in it to ride together. Reverend Foxwell was a surrogate father to her and many others. The pallbearers at his funeral were, from left to right, Raymond Chittam, McKay Vernon, Jay Krause, Joseph Matoski, Vernon Scarf, and Billy McNalley. (Courtesy of Christ Deaf Church.)

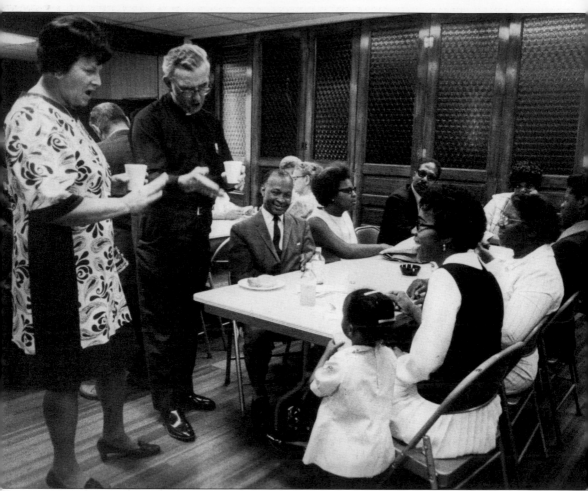

After services at Christ Deaf Church, everybody gathered for either luncheon or refreshments. In this photograph from Easter Sunday in 1970, Reverend Foxwell and his wife, Ruth, greet the guests. From left to right are the Foxwells, Jerome Horsey, May Vance Biles, Alvin Fisher, Devonne Johnson, Donald Chase, Sadie Chase, Grace Neal, Sarah Bouyer, Ellsworth Bouyer, and Grace Neal's two-year-old daughter. (Courtesy of Christ Deaf Church.)

*John 3:16*

*Blessings*

*Rev. Louis W. Foxwell*

This note on the back of a card given by Rev. Louis Foxwell was one of the last things he wrote. A folded newspaper clipping of the story of Foxwell being killed was placed behind the photograph of Foxwell on the front of the card. John 3:16: "For God so loved the world that he gave his one and only Son, that whoever believes in him shall not perish but have eternal life." (Courtesy of Christ Deaf Church.)

Marcia Moylan directed the Sign-A-Thon "Deaf Power" workshop. She is the wife of Rev. Daniel E. Moylan's grandson, Judge Charles E. Moylan Jr. Marcia learned to sign through the church connection and worked as an interpreter for 10 years in the 1980s. (Courtesy of Christ Deaf Church.)

# BIBLIOGRAPHY

*85th Anniversary.* Unpublished book by Christ United Methodist Church for the Deaf, 1980.
*MSD Bulletin.* Frederick, MD: Maryland School for the Deaf, 1897–2013.
*Twenty-Fourth Biennial Report Book, October 1, 1923–October 1, 1926.* Frederick, MD: Maryland School for the Deaf, 1926.
*Twenty-Fifth Biennial Report Book, October 1, 1926–October 1, 1928.* Frederick, Maryland: Maryland School for the Deaf, 1928.

8/19/14

# Discover Thousands of Local History Books Featuring Millions of Vintage Images

Arcadia Publishing, the leading local history publisher in the United States, is committed to making history accessible and meaningful through publishing books that celebrate and preserve the heritage of America's people and places.

Find more books like this at
## www.arcadiapublishing.com

Search for your hometown history, your old stomping grounds, and even your favorite sports team.